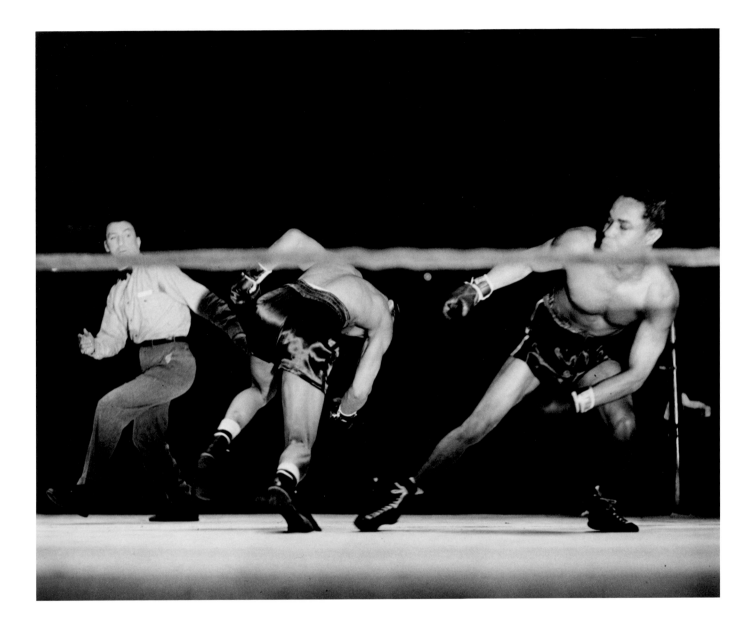

HENRY ARMSTRONG VS. LOU AMBERS, AUGUST 22, 1939

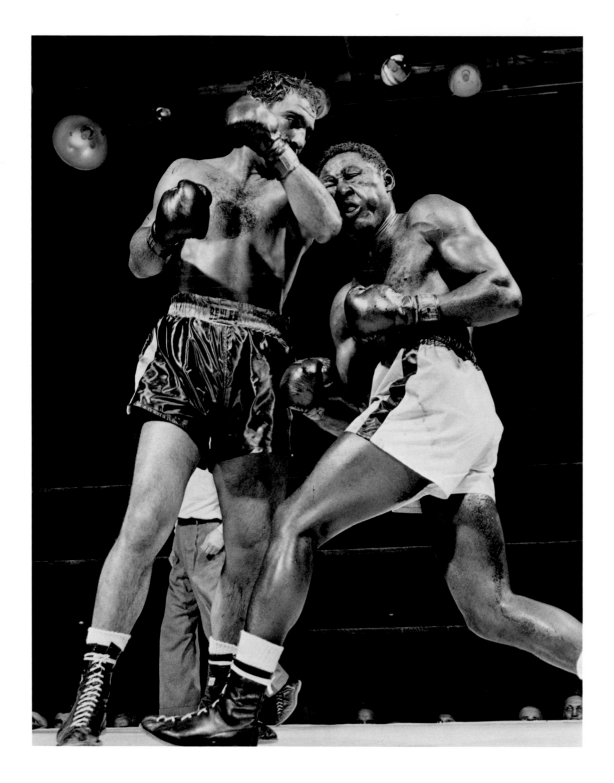

ROCKY MARCIANO VS. EZZARD CHARLES, JUNE 17, 1954

THE FIGHTS

PHOTOGRAPHS BY

CHARLES HOFF

ESSAYS BY

A. J. LIEBLING, JIMMY CANNON,
WILLIAM NACK, JAMES BALDWIN, MARK KRAM

SELECTED AND WITH AN INTRODUCTION BY

RICHARD FORD

A CONSTANCE SULLIVAN BOOK

CHRONICLE BOOKS
SAN FRANCISCO

COPYRIGHT © 1996 BY CONSTANCE SULLIVAN EDITIONS
PHOTOGRAPHS COPYRIGHT © 1996 ESTATE OF CHARLES HOFF
"IN THE FACE" COPYRIGHT © 1996 BY RICHARD FORD
"CHARLES HOFF" COPYRIGHT © 1996 BY RICHARD B. WOODWARD

DEVELOPED, PREPARED, AND PRODUCED BY CONSTANCE SULLIVAN EDITIONS

DESIGN AND TYPOGRAPHY BY KATY HOMANS
PRINTED BY THE STINEHOUR PRESS, LUNENBURG, VERMONT
BOUND BY ROSWELL BOOKBINDING COMPANY, PHOENIX, ARIZONA

PRINTED IN THE UNITED STATES

LIBRARY OF CONGRESS CATALOGING-IN-PUBLICATION DATA:
HOFF, CHARLES. D. 1975.
THE FIGHTS / PHOTOGRAPHS BY CHARLES HOFF;
ESSAY SELECTION AND INTRODUCTION BY RICHARD FORD.

ISBN 0-8118-1122-0

1. BOXING—Pictorial works. I. FORD, RICHARD, 1944- II. TITLE
GV 1133.H64 1996
796.8'3—DC20 96-2604 CIP

PHOTOGRAPHS REPRODUCED COURTESY OF THE NEW YORK *DAILY NEWS*;
PRINTS COURTESY OF HOWARD GREENBERG GALLERY, NEW YORK CITY.

DISTRIBUTED IN CANADA BY
RAINCOAST BOOKS
8680 CAMBIE STREET, VANCOUVER, B.C. V6P 6M9

CONTENTS

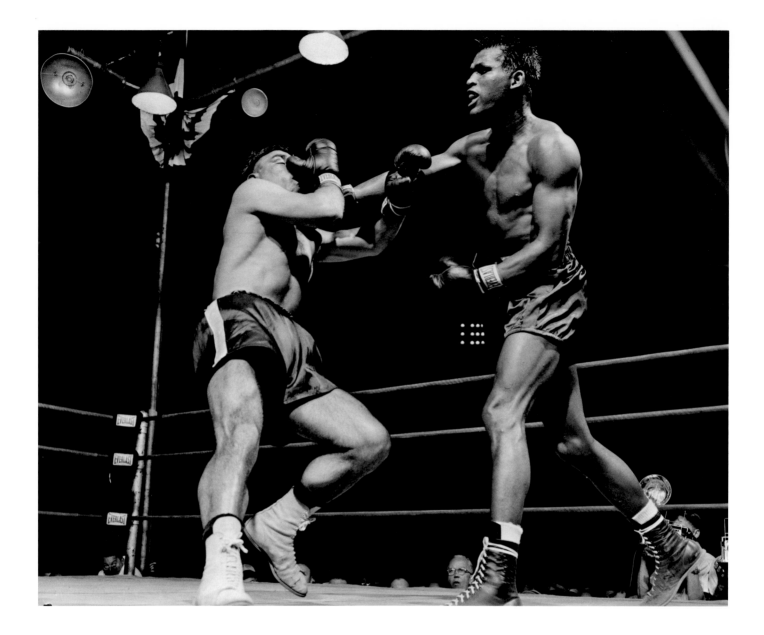

BO BO OLSON VS. SUGAR RAY ROBINSON, OCTOBER 26, 1950

IN THE FACE

RICHARD FORD

I've hit a lot of people in the face in my life. Too many, I'm sure. Where I grew up, in Mississippi, in the Fifties, to be willing to hit another person in the face with your fist meant something. It meant you were, well—brave. It meant you were experienced, too. It also meant you were brash, winningly impulsive, considerate of but not intimidated by consequence, admittedly but not too admittedly theatrical, and probably dangerous. As a frank, willed act, hitting was a move toward adulthood, the place we were all headed—a step in the right direction.

I have likewise been hit in the face myself by others, also quite a few times. Usually just before or just after the former experience. Being hit in the face *goes with* doing the hitting yourself; and while much less to be wished for, it is also (or was) important. It signaled some of those same approved character values (along with rugged resilience), and one had to be willing to endure it.

I can't with accuracy say where this hitting impulse came from, although it wasn't, I'm sure, mere peer pressure. My grandfather was a boxer, and to be "quick with your fists" was always a good trait in his view. He referred to hitting someone as "biffing." "I biffed him," he would say, then nod and sometimes even smile, which meant it was good, or at least admirably mischievous. Once, in Memphis, in 1956, at a college football game in Crump Stadium, he "biffed" a man right in front of me—some drunk he got tired of and who, as we were heading up the steep concrete steps toward an exit, had kicked his heel not once but twice. The biff he delivered that day was a short, heavy boxer's punch from the shoulder. Technically a hook. There was only one blow, but the other guy, a man in a felt hat (it was Autumn), took it on the chin and went over backwards, and right down the concrete steps into the midst of some other people. He was biffed. We just kept going.

There were other times he did that, too: once, right in the lobby of the hotel he ran—putting a man down on the carpet with two rather clubbing blows that seemed to me to originate in his legs. I don't remember what the man had done. Another time was at a hunting camp. A man we were riding with in a pickup truck somehow allowed a deer rifle to discharge inside the cab with us and blow a hole through the door—a very, very loud noise. The man was our host and was, naturally enough, drunk. But it scared us all nearly to death, and my grandfather, whose boxing name was Kid Richard, managed to biff this man by reaching over me and connecting right across the truck seat. It was ten o'clock at night. We were parked in a soybean field, hoping to see some deer. I never thought about any of it much afterward except to think that what he—my grandfather—did was unarguably the best response.

Later, when I was sixteen, and my father had suddenly died, my grandfather escorted me to the YMCA—this was in Little Rock—and there, along with the boys training for the Golden Gloves, he worked out the solid mechanics of hitting for me. The need for compactness. The proper tight fist. The confident step forward. The focus of the eyes. The virtue of the three-punch combination. And it was there and then that he taught me to "cut" a punch—the snapping, inward, quarter-rotation of the fist, performed at the precise moment of impact, and believed by him (rightly or wrongly) to magnify an otherwise hard jolt into a form of detonation. Following this, and for a while, I tried out all I'd learned on the Golden Gloves boys with some not very positive effects to myself. They were, after all, stringy, small-eyed, stingy-mouthed boys from rural Arkansas, with more to lose than I had—which is to say, they were tougher. In years to come, however, I tried to practice all I'd learned, always made the inward cut, took the step forward, always looked where I was hitting. These, I considered, were the crucial aspects of the science. Insider's knowledge. A part of who I was.

I, of course, remember the first occasion on which I was hit in my own face—hit, that is, by someone who meant to hurt me: break my cheek or my nose (which happened), knock my teeth out, ruin my vision, cut me, deliver me to unconsciousness—kill me, at least figuratively. Ronnie Post was my opponent's name. It was 1959. We were fifteen, and had experienced a disagreement

over some trivial school business. (We later seemed to like each other.) But he and his friend, a smirky boy named Johnny Petite, found me after class one day and set on me with a torrent of blows. Others were present, too, and I did some wild, inexpert swinging myself—nothing like I would later learn. None of it, of course, lasted very long or did terrible damage, which is usual with such events. There was no spectacle. No one "boxed." But I got hit a lot, and I remember the feeling of the very first punch, which I saw coming yet could not avoid. The feeling was like a sound more than a shock you'd feel—two big cymbals being clanged right behind my head, then almost immediately the sensation of cold traveling from my neck all the way down into my toes. It didn't particularly hurt or knock me down. (It's not so easy to knock a person down.) And it didn't scare me. I may even have bragged about it later. But when I think about it now, thirty-seven years later, I can hear that cymbals' sound, and I go light-headed and cold again, as if the air all around me had suddenly gotten rarer.

Over the years since then, there have been other occasions for this sort of blunt but pointed response to the world's contingent signals—all responses I think now to be regrettable, and (to me) not very interestingly explainable. (Though I'm certain it's not just a "male thing," since I've seen women do it, too, and have unhappily enough even had it done to me by women a time or two.) But I once hit my best friend at the time flush in the cheek in between downs in a football game where we were playing shirts and skins. We were never friends after that. I once hit a fraternity brother a cheap shot in the nose because he'd humiliated me in public, plus I simply didn't like him. At a dinner after a friend's funeral, of all places, I punched one of the other mourners who due to his excessive style of mourning was making life and grief worse for everybody, and "needed" it, or so I felt. And many, many years ago, on a Saturday afternoon in the middle of May, on a public street in Jackson, Mississippi, I bent over and kissed another boy's bare butt for the express purpose of keeping him from hitting me. (There is very little to learn from all this, I'm afraid, other than where glory does not reside.)

I can't speak for the larger culture, but it's been true all my life that when I've been faced with what seems to me to be an absolutely unfair, undeserved, and insoluble dilemma, I have

thought about hitting it or its human emissary in the face. I've felt this about writers of certain unfair book reviews. I've felt it about other story writers whom I considered perfidious and due for some suffering. I've felt it about my wife on a couple of occasions. I once took a reckless swing at my own father, a punch that missed but brought on very bad consequences for me. I even felt it about my neighbor across the street, who in the heat of an argument over nothing less than a barking dog, hit me in the face very hard, provoking me (or so I judged it) to hit him until he was a bloody mess on the sidewalk. I was forty-eight years old when that happened—an adult in every way.

Even today when, by vow, I don't do it anymore, hitting in the face is still an act the possibility of which I *retain*—an idea—one of those unerasable, personal facts we carry around in deep memory and sometimes re-inventory every day, and that represent the seemingly realest, least unequivocal realities we can claim access to. These are segments of our bottom line, which for each of us is always comprised of plenty we're not happy about. Oddly enough, I don't think about hitting much when I attend an actual boxing match—something I like to do less and less— but where plenty of hitting happens. Boxing *seems* to be about so much more than hitting— about not getting hit, about certain attempts at grace, even about compassion or pathos or dignity. Though hitting in the face *may be* all boxing's about—that and money—and its devotees have simply fashioned suave mechanisms of language to defend against its painful redundancy. This is probably why Liebling, who knew it well, wrote less about boxing than about boxers, and why he called it a science, not an art: because, in essence, hitting in the face is finally not particularly interesting, inasmuch as it lacks even the smallest grain of optimism.

Part of my bottom line is that to myself I'm a man—fairly, unfairly, uninterestingly, stupidly—who could be willing to hit you in the face. And there are still moments when I think this or that—some enmity, some affront, some inequity or malfeasance—will conclude in blows. Possibly I am all unwholesome violence inside, and what I need is therapy or to start life over again on a better tack. Or possibly there's just a meanness in the world and, as Auden wrote once, "We are not any of us very nice." But that thought—hitting—thrilling and awful at the same time, is still one crudely important calibration for what's serious to me, and a guide albeit extreme to

how I *could* confront the serious if I had to. In this way, I suppose it is a part of my inner dramaturgy, and relatable as interior dramas as well as many perversions are, to a sense of justice. And in the end, I have to think, it's simply better and more generally informative that I know all of this, and take caution from it, forebearance, empathy, than that I know nothing about it at all.

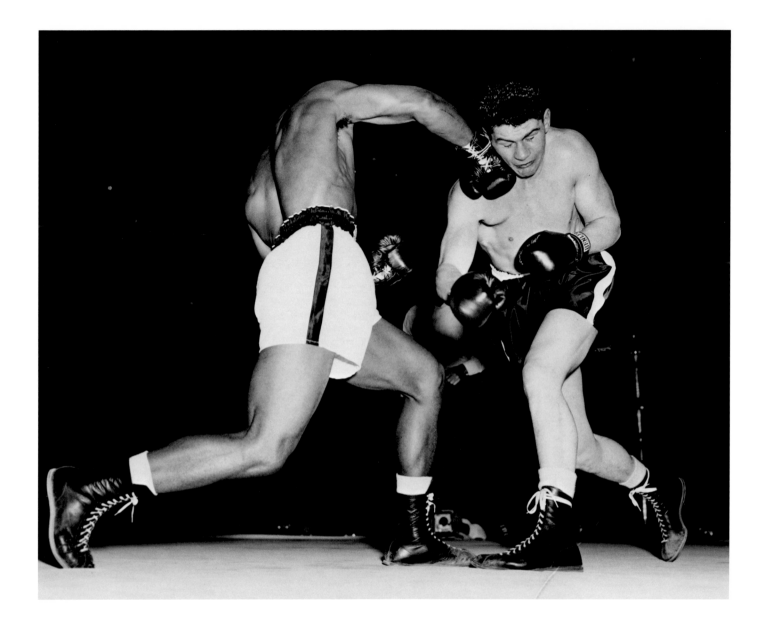

JERSEY JOE WALCOTT VS. REX LAYNE, JULY 12, 1951

NEXT-TO-LAST STAND, MAYBE

A. J. LIEBLING

In April 1955, I went up to Syracuse to attend the second last stand of an East Side welterweight named Billy Graham, who was thirty-three years old. The failing practitioners of most arts may be spared pain by critics who pretend not to notice; if such kindness is in default, they can attribute the critics' changed tone to envy. But a fighter knows when he is slowing up, because he cannot reach the openings he sees. (It is a sensation like the dream in which you swing your fist and it floats.) This intimation is confirmed when fellows who have no right—that is, no professional qualifications—to hit him, do. In fact, they murder him. The public twigs to the situation in infinitely less time than it takes to catch on to a crumbling Hollywood beauty or a souring statesman. Gamblers no longer bet the odds with the fighter but against him, and friends, solicitous of his health, try to dissuade him from further public appearances before he becomes a mere opponent. (A fighter without significance is described as "just an opponent.")

The fighter is as reluctant as the next artist to accept the evidence of his disintegration, even though it is presented to him so much more forcibly. Between fights he is brisk, active, and lusty, since he is still a young man. He therefore refuses to believe his first couple of bad fights, and blames them on negligence; he has not, he thinks, taken the opposition seriously enough. Then he may lose one or two that he will blame on bad decisions—suspecting, though, that if he had been his old self he would have won easily. Finally, or semifinally, his manager will accept a match for him against a younger fighter on his way up. This is known in the cant of the sports page as the "fighter's last stand," although it seldom is, unless it ends in disaster. If the last-standee makes a creditable showing, even in defeat, the fight turns out to have been his next-to-last stand—the first step in a sequence that may repeat itself several times before he finally renounces the active cultivation of his art.

Graham's first last stand, against a twenty-three-year-old fellow—half Chilean and half Italian—named Chico Vejar, in Madison Square Garden on the night of March 4, was a good fight to watch, even though he lost it. Vejar, a tireless, pressing kind of chap without subtlety, carried the fight to him, and Graham, who would have eluded his opponent's rudimentary aggressions with ease a few years ago, had to try to knock him out. For Graham this was a novelty; the chief popular criticism of his best previous efforts had been that they were skillful but unimpassioned. He had started boxing professionally in 1941, and until the beginning of 1954 he was as good as a fighter can be without being a hell of a fighter. While all East Side fighters are traditionally tough, most of the really good ones come from the Lower East Side—from the streets with names rather than numbers, between Broadway and the East River. While Billy was growing up, the part of the East Side he lived in was a crumbling but still almost genteel neighborhood at the foot of the eastern slope of Murray Hill. It centered on St. Gabriel's Church and St. Gabriel's Park and on Billy's father's saloon at Thirty-fifth Street and Second Avenue. There was a long line of neat red brick fronts along the Thirty-seventh Street side of the park, where the East Side Airlines Terminal now stands. The church has since been torn down to make way for an approach to the Manhattan entrance of the Queens-Midtown Tunnel, and the building that housed the saloon fell down of old age. Before these changes came about, the quarter had a provincial air. It had street gangs and street games, but it wasn't enough of a slum to produce a hell of a fighter.

Billy fought plenty of tough fellows who could punch, but he didn't let them punch him often. He was a good boxer inside as well as away, and he made them miss their short punches as well as their long ones. He would hit them enough to win, especially with showy combinations of punches that made him look a bit better than he really was—a knack only his adversaries and their managers begrudged him. Once he came near to winning the world championship from the Cuban Kid Gavilan in New York, but at the end of fifteen rounds the decision went against him. Gavilan was a hell of a fighter having an off night; he fought Graham again, in Havana, and beat him clearly. In 1953, Graham had a good year, beating three determined, hard-punching fellows who couldn't hit him, and making two appearances in Syracuse against a native hero named

Carmen Basilio, who got a decision over Billy in the first bout; in the second, they fought a draw in twelve rounds. But in 1954 Graham began losing to mediocrities, and his first last-stand defeat by Vejar was his third reverse in a row.

Graham's second last stand was also against Vejar. The fight couldn't be held in New York since the circus had moved into Madison Square Garden for a six-week run, so the IBC (Interstate Boxing Commission) put the match in Syracuse because, by reason of his hard fights in that city with Basilio, Graham might be expected to draw well there. (The Syracuse promoter, a young man named Norman Rothschild, was to receive a share of the IBC's television revenue from the fight to protect him against loss in case it *didn't* draw.) Vejar's hometown is Stamford, Connecticut, but he has appeared on television so many times that he is well known everywhere. I went to Syracuse, frankly, because I hoped Graham might have learned enough about Vejar to have a plan for taking the youthful bounce out of him; emotionally, I long ago moved over to the middle-aged side of the field, and I root for mature judgment when pitted against the outrageous fortunes of chronology.

I traveled to Syracuse by train the afternoon of the day before the fight, and when I arrived that evening I checked in at the Hotel Onondaga, a big, convivial old pile, which, while not the most modern in town, got the patronage of visiting members of what Pierce Egan, the parkman of the London prize ring, liked to call "the fancy." I learned at the desk, while registering, that both the fighters, along with their factions—their trainers, seconds, and managers—were in residence. There was no evidence of their presence, however. The bar of the Onondaga had only a few customers, rather than one of Egan's throngs blowing a cloud over the "daffy and heavy wet" (gin and beer) while devouring the rich points of a "flash chaunt" (*chanson à clef*), as there should have been before the combat of two metropolitan heroes in a country town. (Syracuse is the seat of Onondaga County.) I left my bag in my room and went to see how Graham was getting on. The three doors to his faction's suite were locked, but when I knocked at one of them, Irving Cohen, who had been Graham's manager since his first bout, opened it at once.

"Come right in," he said. "Jimmy Wild and I are having a television evening." Mr. Cohen, a

short, plump, blond man, and Mr. Wild, Graham's trainer, a short, plump, dark man, were in their undershirts and shorts; they were watching a televised moving picture that had a star who looked exactly like Vice President Nixon and grinned like him. This chap was trying to find a girl whose picture he had painted from memory. (He had seen her only once, but I came in too late to discover why he hadn't taken that opportunity to ask her name.) Mr. Cohen, who has large, round, blue eyes and a retiring smile, folded his hands contentedly on the front of his undershirt. "A home away from home!" he exclaimed.

Mr. Wild crossed his legs. "Where ya gonna go in Syracuse?" he demanded rhetorically.

I asked about Graham. "He's out catching a double feature," Mr. Cohen said. "We want him to stay up a little late tonight, so he'll sleep late in the morning, not to be restless. We'll wake him just in time to get over to the weigh-in at twelve o'clock."

There are fighters no trainer in his right mind would let get out of his sight on the night before a fight, but Graham isn't one of them. He is an old pro, and a family man. Wild said he had brought Graham up by plane on Monday, three days before; prior to that he had trained for three weeks at Greenwood Lake. In 1926, when Gene Tunney flew from a camp in the Poconos to Philadelphia for his first bout with Jack Dempsey, the flight was intended to be a striking psychological gesture (Tunney got desperately sick), but now it is thought old-fashioned to move fighters by train. "A fighter is conditioned down fine, he goes crazy, five, six hours on a train," Mr. Wild said. "He wants to get where he's going." Wild, I knew, had been with Graham only a short time; Whitey Bimstein, Graham's usual trainer, had been forbidden by the new state athletic commissioner to work in Graham's corner because Freddie Brown, Whitey's partner, was going to work in Vejar's. It was a sore point with the Graham faction. The explanation of the ruling probably is that the new commissioner, a lawyer, had retained in his noodle a legal analogy—that adversaries in a lawsuit should not be represented by the same firm. It is the consensus at the Neutral Corner bar-and-grill that such an analogy is false. The backroom analogy analysts there say that a second is more like a doctor—and can't two doctors in partnership treat two patients in the same room? The commissioner had announced his ruling before the first last-stand fight, and Cohen and

Steve Ellis, Vejar's manager, had flipped a coin to see who would have one of the partners in his corner. Ellis won. After the bout Ellis refused to sign for the return match unless he could keep Brown—an arrangement that would automatically bar Whitey again. Since Ellis's man had won, he had the whip hand. "They're crazy about my strategy," Freddie Brown had told me. Vejar, who is not too smart of a fighter, as the cognoscenti say, was thus equipped with a set of self-propelled brains, while Graham, who can do his own thinking in the ring, was deprived of Whitey's ability to read Freddie's mind and find out what Freddie was likely to tell Vejar to do next. Wild is a capable corner man, but he does not know Freddie as well as Whitey does.

Mr. Cohen said that the contretemps over trainers made no difference with a fighter like Billy, who was no dumb kid. But he ventured to observe that in the twenties, when Whitey was partners with Ray Arcel, Whitey and Ray had worked across from each other almost every Friday night in the Garden—"when it really *was* the Garden"—and nobody had ever accused either of them of doing a client less than justice. Mr. Cohen got into the fight business twenty-five years ago because of his wife's decision to change a small dry goods store that she owned in Bensonhurst into a ladies' specialty shop. Since that left Cohen with little to do around the place after opening up in the morning, he became a fight manager. He still has the manner of the small shopkeeper, however—eager to please and loath to discuss controversial subjects. Probably because he is that way, he got along beautifully as manager of Rocky Graziano, who was middleweight champion of the world between two fights with Tony Zale. Graziano, a rough rhinestone of the ring, would have blown his top under the needling of a more conventional manager.

Graham came in while Cohen was talking about how things used to be in the Garden. For a doddering old gaffer, he looked paradoxically young in his double feature clothes—slacks, a sports jacket in a sculptured lattice pattern, a shirt with the kind of collar that has points so long and so close together that a tie wouldn't show even if you were wearing one. He is of good height for a welterweight—five feet eight or so in shoes—and has a Roman nose, which his early well-wishers said some friend of the family ought to hit him on with a baseball bat, so he would not devote so much thought to defending his profile. At the end of 126 battles, the nose still stands as

an impressive testimony to Billy's cuteness; it has, in fact, been slightly aggrandized by a bump high on the bridge. Today it is a landmark of Stillman's gymnasium, the graveyard of the Barrymore look.

By this time the guy who resembled Nixon had found the girl whose picture he had painted, but none of us had noticed how, since we were talking of other things. The girl, it turned out, was under the influence of a sinister Russian choreographer. The Russian and the Nixon exchanged high words, and at the prospect of a fight the attention of Mr. Graham, Mr. Wild, and Mr. Cohen became, by professional reaction, fixed upon the screen. But instead of squaring off with the Russian, the hero employed a mysterious, invisible judo hold and led him tamely from our view, after which we heard the sound of a blow offstage, as if someone had crushed an inflated paper bag. Mr. Wild got up and switched the set to another show. "I guess they didn't want to spoil the crease in their pants," he said.

"We lose nothing," Graham said. "I never seen a good fight in the movies yet, except a newsreel. They always corny it up."

"I saw one picture where a guy was training in a gym the day of the fight!" Mr. Cohen said, his eyes extra wide with astonishment. "What kind of a manager did he have?" Even children—or at least, fight people's children—know that a fighter *rests* on the day of a fight.

"I seen one," Graham said, "where the two guys are having their hands taped before they put on the gloves, and who does it? The *Boxing Commission physician!*"

"And how many times they always have to be knocked down in the beginning, the heroes!" exclaimed Mr. Cohen. "They got to get murdered or they can't win. The best tip who to bet on in a movie fight is the guy who loses the first fourteen rounds."

"He makes a miraculous recovery," Graham said. "His strength is renewed. But the tops I saw on television last winter—the guy is going to defend the world championship the next night and he says to his wife he is sick of the whole business."

"He's with his wife the night before the championship?" interjected Mr. Cohen.

"He says he won't fight no more," Graham said. "But his little kid, about five years old,

comes in in pajamas and says, 'Daddy, box with me.' So he has to put on the gloves with the kid, and the kid says, 'Daddy, I heard what you said. I'll take your place against that bum'—well, the kid didn't say 'bum' exactly on the television—and the old man begins to cry. So he goes through with the fight and knocks the guy out. How do you like that? What I really go for is Westerns; then I can't tell when they're corning it up."

As I got ready to leave, Graham and the others were watching a show called "Public Defender," in which a man who had a .45, a gray Ford, and a record as long as his arm had been charged with killing a fellow who had been shot with a .45 by a man in a gray Ford. All the public defender had to do was to get him off.

"Good night," Mr. Cohen said to me. "We'll be sitting here some time yet."

Before going to bed I took a turn through the lobby to look for the members of the opposing faction, but they must have been upstairs, too, and it was now too late to go calling. Although the bar had livened up a bit, the customers, I learned from the barman, were not followers of the milling art but basketball fans. The Syracuse professional team, the Nationals, he said, had just defeated the Fort Wayne, Indiana, Pistons, in the first game of the World Series of basketball. Syracuse had won the Eastern and Fort Wayne the Western championship for the regular season. The Nationals' home court was the War Memorial Auditorium, where the milling coves would perform next evening, and the basketball teams would play there again on Saturday, the second game of the World Series. Billy had been crowded out of the Garden by the elephants, and now he was being sandwiched in between two performances of a troupe of human giraffes. In a city the size of Syracuse—population 250,000—it was reasonable to assume that the publics for all kinds of sports would heavily overlap, and that basketball followers, under the necessity of shelling out the bustle twice in three days for the World Series, would skip the fight. The bout was due to be overshadowed in the metropolitan press, too, because there was a more important battle in Boston, where the welterweight champion, Johnny Saxton, was defending his title against a Bostonian named Tony De Marco.

I slept late myself next morning, and then made my way over to the weighing in, at the

auditorium. Syracuse is not one of those cities that win your heart at first glance—which this was for me—but it was a fine day. In the Onondaga Coffee Room, I had observed the members of the Fort Wayne Pistons having breakfast. They twined their long legs around the table legs or doubled them back under the chairs. It occurred to me that life must be very difficult for a traveling collection of men who are from six feet six to nearly seven feet tall. They might have special long beds at home, but they could scarcely carry them with them, and they must either bend or step back several paces to look in a shaving mirror. An awareness of their altitude seemed to oppress them—I could imagine how many times they had been asked how the weather was up there—and their heads, at the ends of such long necks, looked small, like guinea hens'. I was rapidly becoming depressed myself, until I thought of what a liberation it must be for a man of that height to get into the company of others who could see eye to eye with him. Instead of feeling himself set apart, he probably begins to think of anyone under six feet five as subnormal. He goes back to his hometown a giant refreshed.

Arriving at the auditorium, the outside of which is carved all over with the names of battles, from Belleau Wood to Iwo Jima, I was further gladdened by the sight of a number of familiar Eighth Avenue faces. Freddie Brown and Chickie Ferrara were there with Vejar, who is a shorter, but more compact, welterweight than Graham. So was Ellis, a swarthy, hand-pumping kind of man who, aside from being a manager, narrates sports events on television. Brown was in an expansive mood; another fellow he trains, named Giovanelli, had scored a knockout earlier in the week against a four-to-one favorite, and he must have felt that this was a good omen. Cohen and Wild were on hand with Graham, whose beard showed dark through his pale skin. Vejar's tawny cheeks seemed beardless. A moonfaced, jolly trainer named Jimmy August had driven up from New York with a middleweight named Ray Drake, who was fighting in the semifinals. Drake, like Graham, is a student of the niceties of tactics, specializing in leverage. An expeditionary force from the IBC office in New York had also appeared under the command of Billy Brown, the Garden matchmaker, who was no kin to Freddie. All the briefly expatriate faces shone with a special polish for their out-of-town adventure, reflecting, first, a *souci* for the big town reputation for

elegance, and, second, a realization that, as Whitey Bimstein had long ago observed to me, "Out of town, anything is liable to happen. You gotta keep your eyes open every minute." On the scales, before an Athletic Commission inspector, Graham weighed 149½ pounds and Vejar 154½, or 2½ pounds more than he had for their first fight. When, after being weighed, the two men posed together for the Syracuse newspaper photographers, the difference in their ages was more apparent than when they wore clothes. Graham was in excellent trim, but his pale skin appeared stretched over his lean body, while Vejar's darker skin seemed molded to his flesh to form a single substance. The Graham legs, which had served him well so often, looked spindly compared to the younger man's. Some joker called to Billy, "How ya feeling, Pop?" and he didn't look too pleased.

I spent the afternoon walking around Syracuse and appreciating the weather, and then had dinner with a fellow I had known during the war, who was now a clubman and engaged in the paper business up there. He said that by then the odds were two to one on Vejar. My friend and I arrived at the auditorium just before the beginning of Drake's bout. My forebodings about the gate had been borne out. The basketball patrons had stayed away, and the hall was only about a third full. The New York newspapermen had gone to the Boston fight, and Billy's second last stand would be chronicled exclusively by the press associations and the locals. With the house lights out, though, there was a feeling of a crowd and of partisan excitement. A fight crowd in a secondary city like Syracuse is different from one in New York or Chicago, or even Philadelphia—when there is a local man fighting, it is intensely partisan; when both are outsiders, it is objective and skeptical. In this case, Drake was boxing a boy from Poughkeepsie, and although that city is much nearer to New York than to Syracuse, it shares with Syracuse the mystic quality of being upstate, which means in permanent, suspicious opposition to the metropolis. The Poughkeepsie entry, a redhead named Eddie Prince, consequently got a lot of encouragement and benevolent advice, while Drake, who prides himself on a worldly, self-possessed air, impressed the crowd immediately as a fellow one couldn't trust.

Prince, who had an honest face and a willing heart, fought from a semicrouch, hitting hard but seldom anything. "Short moves, Eddie, short moves!" the fans who had adopted him called

when he missed his long punches. When Drake took him by the right elbow, as if helping him to alight from a taxicab, and then shoved him gently away and hit him with a left hook, a Syracusan shouted, "None of that Bowery rough stuff!" Drake boxed rings around Prince, who kept trying, however. Drake's good will was evident; on one of the two occasions when he pushed the upstater all the way through the ropes, he helped pull him back; on the other hand, when Prince kicked Drake in the instep, the chawbacon did not even stop to shake hands. In the fourth round, or perhaps the fifth, Prince scored a clean and unexpected knockdown. (Drake later said that he had seen the right starting but, instead of forestalling it with a conventional left, had tried to beat it with his own right. "It was incorrect," he said. "He hit me right on the chin.") Rising, disdainful, although forced to accept a count of eight, Drake resumed his demonstration of how to keep your feet even when the ring seems greased for your opponent. "Floor him again, Eddie!" the upstate Republicans chorused, and after every round they yelled to the referee, "Take that one away from Drake!" Annoyed by his own incorrect reaction to the right hand, Drake showed no elation when he got the decision. He is a perfectionist and, I fear, doomed never to be satisfied.

It was a nice fight, providing an excellent emotional warm-up for what was ahead. A pair of powerful Black heavyweights then went at each other for four rounds, going the distance rather to their own astonishment. The bout ran over into television time, so Graham and Vejar were allowed to go about their business without further delay.

Graham had found in his first last-stand bout that he was no longer fast enough to outbox a man like Vejar all the way; the Stamford fighter had a good jab and quick reflexes, as well as plenty of bottom, which is the London prize ring word for stamina, and sounds better. He had also found that he couldn't make his own pace—resting and then spurting, and so winning a series of short fights instead of one long one. This was because Vejar wouldn't let him rest. The younger man could go the whole ten rounds at a fast rate. And Vejar wouldn't spurt when Graham wanted him to, which, of course, was when Graham had already hit him and was in position to hit him again. For a young fellow, and a Latin, Vejar is a cool customer. He is not, however, an exceptionally dangerous hitter. Billy didn't have to worry much about Vejar's taking him out

with one punch. In none of Graham's 125 fights had anybody ever done that. In their first fight, though, Graham had nailed Vejar with several beautiful rights to the head—some almost straight punches and some that were more conventionally angled in. I had never before seen him stand so flat or punch so hard. So I suspected now that the older boxer's best chance to win might be by knocking the rough young slugger out, but I didn't know how Billy was going to go about it.

In the first round Billy didn't enlighten me. He boxed with the habitual Graham elegance. Going under Vejar's elbows and around him, flicking him with long lefts, like an old-fashioned lightning portrait painter in a variety show, and occasionally getting in a stylish left and right to the body, he made him look crude, but Vejar's jab, when he landed it, appeared to have more power; in fact, it looked faster. Vejar punched away, too, and although he missed any target worth aiming at, his blows landed on Graham's arms, his shoulders, his back as he ducked under punches, and his ribs now and then in clinches—all attentions calculated to take some of the steam out of a fellow of Billy's seniority and to impress the judges, at least, with Vejar's aggressiveness. The referee, Ray Miller, who was once a good fighter himself—maybe even a hell of a fighter—could be relied on not to be overimpressed, but judges are usually less discerning. I wouldn't have given Graham that round myself, for all my admiration of him. After the bell, he looked virtually middle-aged. His hair, which he wears rather long and flattened to his head, hung lank, the gloves had left welts on his white skin, and his nose had been reddened, although not bloodied, as if by a prolonged course of the daffy.

It was clear that salvation did not lie that way; there was even a danger that Vejar would wear Graham down and have him hanging on before the end. The second round was better; Billy caught Junior with one hard right, but Chico got away and took the curse off it with more flurries of elbow busters. In the third, Graham seemed to be tiring, and after that it was all Vejar for a while. Graham's defensive boxing was brilliant, but he didn't even look like he was trying to score points with his left. He was in, under, and out a lot, leaving Vejar looking silly and baffled, but the boy was doing most of the punching, such as it was. I had Vejar winning five of the first seven rounds, and one even.

Then, halfway through the eighth round, Graham nailed Vejar with a right as the boy came off the ropes on the opposite side of the ring from where I sat. Vejar tried to counter and Billy hit him again; Vejar tried to slip away and the right went in a third time. Graham landed at least five hard rights to the side of the head within five seconds, but none hit the jackpot, and the strong young legs carried Vejar away. Blood was streaming from a cut behind and above his left eye, and the theretofore neutral, half-contemptuous crowd—"That'll be all, Willie!" they had been yelling a minute earlier—roared for Billy to finish him. He tried with the prescribed calm to set the boy up, but he couldn't. His legs wouldn't keep him close enough. The clock over the ring showed thirty seconds of the round left, then twenty, and the classic boxer discarded finesse. With his lank locks flying around his head, he stood flatfooted and threw the right after Vejar's circling form like an old woman throwing a pie, but then the round ended, and he walked very slowly to his corner, while the fighter with a future stumbled toward the ministering arms of Drs. Brown and Ferrara. Brown, who stops the flow from the mountainous crevasses in the craggy countenance of Rocky Marciano, did one of his customary jobs on Vejar. The boy came out looking like the "after" picture in a "remove unsightly blemishes" ad.

Graham's grim task was to open the cut again, but this objective was so obvious that it put him at a tactical disadvantage. Vejar knew what Graham had to try to do, but Graham didn't know what Vejar was going to try to do. All he *had* to do was keep the left side of his face intact and he would win the decision, even if he lost the last two rounds. Actually, Vejar did better. He caught Graham with a left hook that turned him halfway around, which would have been unthinkable if the cute boxer hadn't been so intent on getting that right over. Later, Graham hit the patch once—blood showed again—and then the round was over. The last stand would have no movie ending.

Both men came out strong for the final round—"very gay," Egan would have said. It was a fine, hard round, and Billy won it, I thought, but there was no doubt where the decision would go. It was unanimous for Vejar.

After the fight, I went back to Graham's dressing room. All the veteran artist's wounds were

on his back and shoulders—probably scrapes from glove laces—although the nose showed an extra bump, and he stood taller than ever. Also, Graham had somehow developed a painful blister on the big toe of his left foot. Everybody said he had made a great fight—better than the one in New York—and I asked him if he had been trying from the first to set Vejar up for the right. He said, "Yeah, but he knew I was looking for him." He talked to Cohen and Wild about the blister on his toe and they decided not to cut it. He was talking easily, as if he hadn't been fighting. His wind was good. After a while he said wistfully, "Gee, did you see that cut bleed in the ninth when I hit it just once?"

Wild said to me, "We were going for his gut in those middle rounds, to bring his guard down. But he wouldn't go for it. Anyway, this guy couldn't get in there like he could have once."

A reporter for a press association asked Cohen whether Graham would retire now, and Cohen replied, "We are withholding any announcement at present."

Half an hour later, I was at the Onondaga bar again, waiting for train time, which was a couple of hours away. I was with my Syracuse friend who is in the paper business, and I was lamenting my failure to have bet on a horse named Bobby Brocato, which had won the feature race at the Jamaica opening and paid nineteen to one. I was sure that if I had been there, I would have played him. We were also discussing the news from Boston. The Boston fellow, De Marco, had knocked out Saxton in the fourteenth round and won the welterweight championship. The paper man said, "You could have had three to one against him."

We were standing at one end of the bar, near the telephone. Graham came in, wearing a dark suit with a tie, and put in a call to his mother. He drank beer with us while he waited for the call to go through; he was pretty thoroughly dehydrated. After a while he got the connection, and said, "It's me. . . . I'm all right. . . . Sure." For such an old, ringwise fellow, he sounded strangely like a small boy minimizing a bad school report card. His mother must have known by then how he'd made out, if she had a television set or neighbors. After listening to her for a bit, Graham said, "Oh, sure. They're all satisfied. They all said I made a good try, but I guess it wasn't good enough."

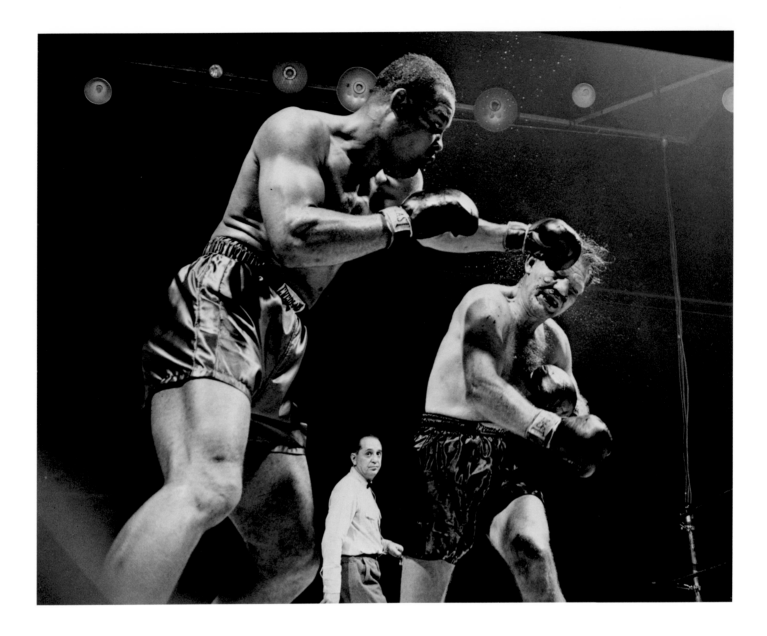

JOE LOUIS VS. LEE SAVOLD, JUNE 15, 1951

26

ROCKY GRAZIANO

JIMMY CANNON

The room service waiter rolled the table into the parlor of the suite, and five of them sat down to eat breakfast. There were people sitting in all the chairs, on the sofa and along the window seats. They were the seconds, the managers, the friends and relatives of Rocky Graziano. The fighter, who wasn't wearing a shirt, was pointing out the sailboats which lay at anchor in the small harbor of the lake. The fighter's daughter, who was in his arms, snatched at the pipe in her father's mouth and began to pull it, but he jerked away and explained it would burn her.

"What is your father?" asked the fighter's wife, a dark girl, who was mixing the baby's cereal.

The child squirmed in Rocky's arms and hung her head.

"Come on now," the fighter's wife asked. "Tell the people what your father is."

"Let her eat first," Rocky said. "It's too early for a show."

The child pushed her head into the fighter's neck and then spoke, with the words muffled.

"My father is the greatest fighter in the world," the little girl said.

The fighter's wife said it would be impossible for her even to go into a gymnasium where Rocky was working.

"I don't like to see him fight," she said. "I listen to the radio when he fights. Half and half. I like to hear the news in dribs and drabs. I run in and out of the room where the radio is. I want to hear it and I don't want to hear it."

I asked her where she was the night when Tony Zale knocked Rocky out.

"I was home," the fighter's wife said. "My mother was with me. I ran all the time. I tried to hear as little as possible. Once I tried to watch him train at Greenwood Lake. But even that made me nervous and I couldn't stand it. I'm more nervous than he is. But the last time, the time Rocky got knocked out—to tell you the truth I couldn't believe it. It was quite a shock."

The child tipped over the milk, and it ran in a white brook along the tablecloth and dripped onto the dress of the fighter's wife. The child started to cry, and they all watched her until she stopped and began to eat again.

"No matter if Rocky wins or loses," the fighter's wife said, "he comes right home. I don't have any feast ready for him because he is always too excited to eat. He dives into some cake he hasn't had for a long time on account of the training or he eats some candy. It was bad after the Zale fight. But I tried to control myself. I didn't want to show him how I felt. We tried to cheer him up. I couldn't say anything. I had a lump in my throat. He couldn't say anything either. Just had a sheepish look on his face. That's how we were that night. Not saying a word. But some people came in and I was all right."

One of them in the room said the fighter's wife would be glad when it was over and she could lead a normal life. The fighter's wife disagreed with him.

"Maybe I feel that way now," she explained. "Right now when he's fighting I wish he wasn't and he had a job somewheres. But I'll probably miss it when it's over. It gets into your blood. Rocky was just beginning when I met him. He was just starting to box and it seemed so exciting and wonderful. It was something different for me. It is still wonderful . . . all the excitement . . . except for the tension on the night of a fight."

Graziano was reading the Chicago morning newspapers and came to a picture of his wife.

"He gets more of a kick out of seeing my picture in the paper than he does his own," the fighter's wife said, proudly. "But right now his whole life is fighting. I'm glad I've come to Chicago. I'm really finding out the little ins about fighting. I thought training was easy. I always said Rocky has a good time training for a fight. Now I know what it's about. It's hard work."

But no matter what might happen the following night with Zale, it would never be like the night Rocky knocked out Billy Arnold.

"It was like the beginning of a new life for us," the fighter's wife said. "We were starting all over again. That was the fight when he was such a big underdog. But when he knocked out Billy Arnold, it meant he was going to be somebody. That was do or die. That was being on the road

up. It is still hard for me to believe he may become the champ. But I don't want to even hear this fight on the radio. I'm going to lock myself in the bathroom and sit in a tub full of water until the fight's over."

There was a knock on the door and Whitey Bimstein, the trainer, opened it. There was an old lady standing there.

"Grandmaw," Rocky yelled and ran to kiss her. He turned to the people in the room.

"Eighty years old," he said. "Eighty years old and she comes to Chicago to see the black sheep."

There was another knock on the door, and an uncle came in. They sat around and listened while the fighter's daughter said the old man was the greatest fighter in the world.

It was when Rocky Graziano was middleweight champion of the world, after they picked up his license. At the time he was not permitted to fight in New York because he had neglected to report a gambler who had offered him a bribe to go into the water in an unimportant fight. The people who did his business had pleased the National Boxing Association by putting him in with Sonny Horne in Washington, D.C. They had accepted a dollar as their end and donated the rest to charity. It was not only an act of philanthropy, but a smart move by the fight managers. After the fight, which Graziano won, we sat up all night on the train, and it was still dark when we went into the restaurant in Penn Station in New York. On the stool next to Graziano was an old man, filthy and murmurous with the whisperings of lunacy. He paused in his unintelligible soliloquy, which was addressed to his oatmeal because the big place was empty, and regarded Graziano with a near-sighted hostility. The counterman recognized the fighter and was impressed. The old man muttered profanely, mysteriously offended because Graziano sat so close to him.

"This is Rocky Graziano," the counterman said. "The middleweight champion of the world."

"How you doing, Pop?" Graziano said.

"What does Rocky Graziano mean to me?" the old man asked angrily.

The old man soaked his corn muffin in the coffee and raised it, dripping and crumbling.

He pushed it into his whiskers as though the mouth, hidden by the hairs, was sealed and he had to force an opening.

"Be my guest," Graziano said. "Eat up big."

"You can't bribe me with a meal," the old man said.

The beard looked like a nest for untidy birds.

"Am I going to have trouble with you, too?" Graziano asked.

"Prizefighters are nothing," the old man said, and spat to accentuate his contempt.

"Who are you?" Graziano said. "The district attorney? Leave me alone. We're pals."

"What happens to prizefighters?" the old man said. "What happens to all of you?"

"You got me," Graziano said. "Why don't you eat something? Order anything you want."

"They're all lunatics," the old man said.

"Did you ever hear of Stanley Ketchel?" Graziano asked.

"He's dead," the old man said.

"You ever box?" Graziano asked.

"Me—box?" the old man said. "I'm sane."

"How do you like that?" Graziano asked. "Now I'm a bug."

"You know what happens to prizefighters?" the old man said.

He stood up, a tall man, crouching a little so that his face was close to Graziano.

"They go crazy or they wind up in the gutter," the old man said, his voice rising with hysteria.

The old man looked at Graziano, his face twitching and his body shaking, and then he left, laughing and hysterical.

"What am I?" Graziano asked us, the people with him and the counterman. "Am I a jerk?"

He turned to me.

"I get that wherever I go," he said.

"What's that?" one of the handlers asked, but he knew what Graziano meant. We all did.

"About being punch-drunk," Graziano said.

"Punch-drunk," the guy said. "You ain't punch-drunk. You're the champion of the world, and there's a bum ain't got coffee money."

"Ain't they got any manners?" Graziano said. "Asking a fighter a thing like that? You'd think that people up in the country would have some sense. I'm up in the country training, and they're always asking me when a fighter starts getting punch-drunk. I want to hit them a shot when they start something like that. What are they—crazy? Asking a fighter if he's getting punchy. Ain't they got no manners at all?"

"How could you be punch-drunk?" one of his own people said.

Insanity frightens Graziano; ignorance delights him. Once I ate dinner with him in a restaurant on the East Side of New York. We were joined by an amateur boxer, a handsome boy who had a soft-voiced humility.

"Spell *school*," Graziano said suddenly. The kid's handsomeness was marred by the terror of stupidity.

"Spell *school*, Graziano insisted.

"I can't," the kid said, smiling.

"Spell *school*," Graziano said.

The boy closed his eyes in painful reflection and didn't open them when he spoke with an unexpected stammer.

"S-k-u-l," the boy said, the letters spaced very far apart.

"Fifteen years old and he can't even spell *school*," Graziano said, as though he had witnessed a remarkable achievement.

There was a guy standing at the bar.

"See him," Graziano said, pointing to the guy. "He can't even read or write."

"Aw," said the kid who couldn't spell, "I can't read or write good either."

"You're brilliant compared to him," Graziano said.

The statement upset the boy.

"I bet I read and write worse than him even," he bragged.

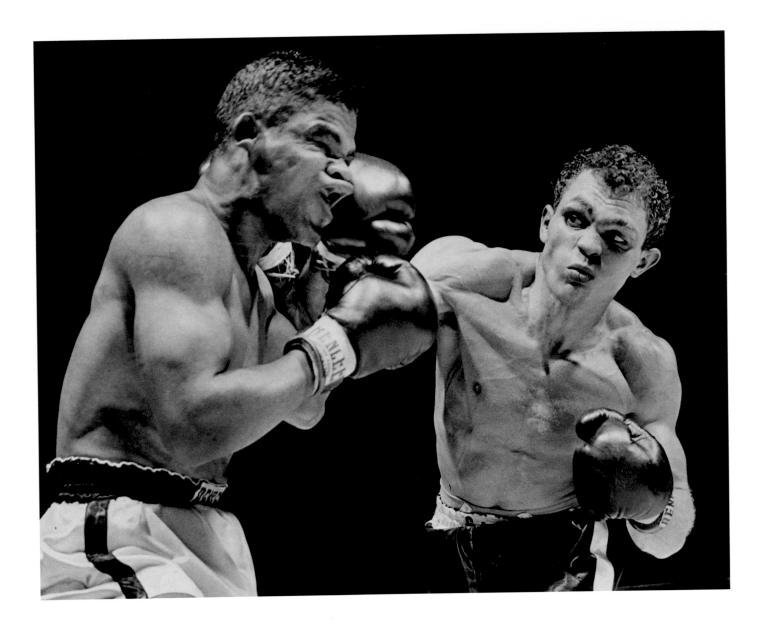

LEN MATTHEWS VS. CARLOS ORTIZ, APRIL 13, 1959

TONY ZALE: WORKING MAN

JIMMY CANNON

The reporter who covers games appoints himself an authority on courage as soon as the assistant sports editor puts his name down on the assignment sheet. We demand that the athlete be perfect in competition and proceed on the theory that he should be exempt from fear. We can be timid and frightened in our personal lives. But we are cruel judges of human behavior when we settle down to play our pieces on the typewriter. We may move down the bar when a guy gets stormy. We allow ourselves to cross the street or walk in the gutter when a man approaches us late at night, and our excuse is that he may be a stickup guy. We permit cab drivers to address us with a profane insolence. We may take this as we are on the way down to the office to denounce a young man because he was not brave according to the standards we have established for his sport.

No other group in the newspaper business is as severe in its judgments of a man's behavior as we are. If we did it in any other department, we would get ourselves a libel suit every time we went to the post. The literature of the sports page is devoted to sizing up a man's capacity to endure pain and humiliation. In the saloons where we gather we argue about it endlessly. We are cruel in our appraisals, and we do it with the belligerence of people who are protected from physical danger by the nature of our jobs. There are few among us who have compassion for the quitter. We make fear in a man playing a game a crime against his sport. But we never know the truth and must forever doubt our own conceptions of what we see in guys who use their bodies. Each man's capacity for fear is different and forever a secret within him. It is impossible to investigate this in a man because if he wants to conceal it there is no way you can probe for the truth. The psychoanalyst is defeated when his subject lies about the terrors which populate his mind. The demands change with the game, and you must shift your philosophy as the seasons turn. Cowardice disgusts you no matter where it happens, no matter what form it takes. Bravery exalts

a man. It can be pointless and done for dirty reasons, but the act itself never has demeaned the human race, although it is possible the motives may sicken you.

It always annoys me when I watch a football player step outside to avoid being tackled because you know he is fracturing the laws of the competition. He is committed to these dogmas when he goes onto the field. The pitcher who refuses to come in with the curve when he is in trouble is a guy breaking baseball's code of deportment if the curve is his best pitch. It does not involve physical suffering, but an act which disgusts the players who obey the mandates of their sport and go with them, no matter what the consequences may be. Basketball players quit in devious ways, and even the gentle jostling of such a sport may turn a man out of the pattern of his skill. This misbehavior is hard to detect and difficult to write about because even when you see it you are never sure. Golfers surrender their talent to the foe when their nervous systems become under pressure. So do tennis players, and they are not gambling their health or their sanity. What is asked of other athletes is trivial when you compare them with the prizefighter. Others seldom bleed. Their bones do not break. Lunacy is not the reward of many defeats. There is no privacy for the coward in the fight racket. It does not make it better, but the truly game man is appreciated more in boxing than in any other sport. It is preposterous to say a tennis player or a golfer is game and then use the same adjective when you are describing a fighter.

The bad ones sit in their corner and refuse to come out if they are taking a licking. There are those who appeal to the referee to save them. Legitimate punches in the body make them complain they are being fouled. Some go down and stay there when they can get up. Although he is hurt and sick with punishment, the fight racket insists that a pug come up and take it until insensibility gives him a pardon.

Of all the fighters I have watched, Tony Zale is the guy most faithful to this unreasonable demand. It is his philosophy that a fighter must go as far as his strength will take him, and this is a journey he is prepared to make every time he goes into a ring. Zale has a terrible knowledge of what a fighter should be. You must live by the cruel laws of the ugliest of all sports, or you are fleecing the people who pay to see you fight. When you sit and talk to him or when you watch him

at his bloody trade, you realize what the good ones are. There have been champions who had more ability then Zale, but there was never one who had more dignity. I will always remember Zale as the fighter with the most complete understanding of his profession. The filth of it never mussed him up. It is not important what happened after his three fights with Rocky Graziano, and what went on before that is incidental, although his life outside of his profession made him what he is. What he did before he became a fighter shaped him into a man who has that poise of complete gameness which transcends the sport and should not have been wasted on it. The three fights with Rocky Graziano were among the best fights I have ever seen, and it does not matter that he was a champion before or how long after that he held the title. They were brief but violent encounters.

These were fights which the reformers can use as a reason why the racket should be run out of the arenas and ballparks, and made as illegal as the peddling of cocaine. They were great fights because Zale is a man consecrated to the brutal ideals of his calling. Such purity must be appreciated even when the cause is without value and a selfish crusade entered into for money. Such a fight enthusiast as John McNulty, the short-story writer, was revolted by what he saw and the next day in his newspaper column declared that his enjoyment of fights was spoiled. But if there must be a prizefighter, it should be Tony Zale, even though he frightens me.

Zale's is not a flashy gameness. It is not blemished by bragging. It is the valor of the workingman doing a dangerous job. It gives him the majesty of workingmen everywhere who take chances because such jobs pay them more than employment where no harm is involved. It is a savagery which is not connected with anger, and this should make it unclean and repellant. Such pompously calm brutality would disfigure another fighter because Zale's dedication gives him the rigid isolation identified with men who despise society. But there are decent reasons why this man accepts his right to be a champion even when he does not have the title. This is a man who possesses a talent for aggression and uses it only to make a living. He knows the way the world is. There are few men who do, but it is a cynicism which has not debased him. Inflicting injury on another man is a skill they will reward with money, and the flattery that follows the recognition of

such a gift has not impressed him. Because he knows exactly what he is doing and why, what he does has not mangled his character. He takes whatever happens in the course of a fight and realizes that the only way to minimize your own agony is by beating the other man. As he works on his opponent, his violence has the skilled laborer's devotion to the requirements of a complicated craft which he suspects is close to the realm of art.

Loneliness frequently endows a man with an accidental splendor of character. The lonesome man is often inarticulate, and this establishes a bogus mystery and tantalizes all those who seek to find his value. Such guys taunt you with their aloofness and betray you into elaborate and erroneous suppositions. Zale is not one of these. He is a man who can explain what he is. But before his first fight with Graziano, I sat with him on the porch of an old house near the village of Pompton Lakes, where he trained. I had never met him before. All I knew about him was down in the record books. But I had the word of two of his opponents that he was a guy you couldn't discourage. They had both beaten him, but they were eager to explain what a truly game guy he was.

"He hits you in the belly," Billy Soose said after their fight, "and it's like someone stuck a hot poker in you and left it there."

Billy Conn, who was a heavyweight, said there was no way you could make him back up.

"He hit me a rap in the body," Conn said. "I said the hell with this. I stuck him and moved. He chased me all night."

I told Zale this when I met him.

"I was disappointed when I fought Conn," Zale said. "He beat me, but he proved he was not the fighter he was supposed to be. The guy wouldn't come to me. I had to go after him. I didn't think he was that kind of a fighter."

Most fighters must justify every defeat. They do this to prevent the disapproval of the spectators and the matchmakers who decide the amount of their pay. They search desperately for excuses and use them to influence public opinion. Zale demands an alibi for his own private use. It is necessary for him to find reasons which will not damage the esteem in which he holds himself. He is a man proud of what he is and what his body can do. He moves with a stiff-boned

grace. He walks the way he believes a champion should. It is as though he has rehearsed this pose many times. When you see him, briskly erect, mildly swaggering, the way a garrison soldier marches in formation, it becomes a feat of control. At first I thought it gave him a quality of slyness, as all tricks do. I don't pretend I know him well, but I have been around him a lot. He is a difficult man to interview, being polite and austere and very miserly with his conversation. But what small knowledge I have of him convinces me that he is a man who has developed an authentic character the way the average guy gets a suntan. It is part of him as a man's skin is, no matter what the sun does to it. In Zale is the old respect men once had for champions in this country. It is a clear idea of what a champion should be, and not a bad one. It might be wrong in other fighters. But Zale is entitled to this estimation of himself because all those who know him or have seen him fight agree with it.

I asked him that first day I met him why he was a prizefighter.

"The fellow who was hungry once realized what it was," Zale said. "He don't want to go back to it."

"What don't you want to go back to?" I said.

"The steel mills," Zale said.

"Was it tough?" I said.

"Did you ever snipe cinders?" Zale wanted to know.

"No," I said.

Zale said, "It's very bad. You don't make much."

"Is it tougher than the fight racket?" I asked.

"You get more out of fighting," Zale said. "When a guy don't want to go back to a certain thing, that's what makes him fight. You fight to keep away from being hungry. But some guys get there fast and easy, and they think it's always going to be that way. Soon as they think that, they find themselves going in the opposite direction."

"You quit fighting once," I reminded him.

"I went back to the mill."

"Why?"

"Mismanagement," Zale said. "What's the use of fighting if you don't get anything out of it? After a few fights they put me in with Kid Leonard, a pretty good fighter in those days. I got beat in ten rounds. I didn't get nothing for it. I went back to Gary. I knew I was going to get away from the mill. I knew I was a fighter. I kept in shape. I worked out fairly regular. Sniping cinders keeps you in shape, too. The job hardens you up. Too much of it will bring a man down. It's no good if you got to do it all your life. What do you get out of it? It just brings you down and you're liable to be looking for a meal. You get money out of fighting."

They made Graziano a big favorite the first fight. They said Zale was done and his long hitch in the Navy had destroyed him. They remembered he never had an easy fight and he went down when they nailed him right. Graziano was a puncher. He didn't know much; he was young and strong; his right hand was wild but powerful. Graziano was down in the first round. He survived it, and it did not seem to sap his strength or rob him of his senses. Going into the sixth round, Zale appeared to be used up and finished. He moved jerkily, and there was no indication that he could get through the round. It seemed hard for him to set his arms into the fighting pose. But, out of this twilight, he punched to the belly and then to the head, and Graziano went down. Ruby Goldstein, the referee, counted ten, and as he reached the final number Graziano jumped up and insisted he wanted to fight. I went to Graziano's dressing room first. He was alert and unmarked, and gabby with the conversation of the perplexed. After I had left, he talked to Al Buck, one of the best of the boxing journalists.

"He will knock me out again," Graziano said to the astonished reporter.

Over in the locker room where they dressed Zale, he was sitting on a chair with his right hand in a pail of ice. He seemed like a man who has been dozing in the sun and wishes to perpetuate a languor and avoid conversation because it might disturb his mood. We asked him questions. He smiled serenely, ignoring their meaning, giving the same answer to all of them.

"Clean living . . . clean living," he said over and over again, smiling as though this had a private meaning of great significance.

Finally, a reporter said. "This guy's knocked out."

It took three handlers to get him to the shower. They held him under a long time.

Graziano had knocked Zale out, but his body still obeyed the instructions of his mind, and he had refused to fall down. He had punched because that is what a fighter is supposed to do. That is what they pay him to do. It did not occur to Zale that his was unusual. You are sent in there to fight, and that is what you do as long as you can, no matter what happens to you. You don't decide whether you fall down. You don't depend on flight if you are a puncher. You do exactly what Zale did.

But there aren't many of them who figure it that way. It is part of the job, the licking, just as the big pay is. Zale is prepared to accept both.

The second fight was held in Chicago because Graziano's license was revoked in New York when he refused to identify a gambler who had offered him a bribe to go into the water. It was fought indoors on a hot summer night, and no cooling device was employed. A guy with a thermometer in the working press section claimed it was 100 degrees. It must have been more than that under the lights of the ring, and the smell of the crowd was enough to turn your stomach. It was Zale's fight for four rounds, and he closed Graziano's eye and ripped it, and the blood covered them both. Graziano was in torment from a body beating, and his mouth opened after punches as though he were about to vomit. In the fourth round Zale suddenly stopped, and in the sixth round the referee, Johnny Behr, ended it, and Graziano was middleweight champion of the world. Zale was bent over the ropes, a posture which suggested that his bones had melted in the unnatural heat. Graziano was still punching at him. It was the opinion of many that Zale would have been dangerously injured if it had gone any further. But such a finish displeased him. He protested because, according to the code by which he lives, a champion should lose his title on his back. He was on his feet, and the referee should have permitted him to lose honorably. It violated his creed that a man must go as far as he can, and he did not accept this distance as the whole way. Again his pride goaded him into finding a reason why he was beaten by a man he had once knocked out. The heat was his explanation this time. The atmosphere had deprived him of his

championship, not Graziano. The weather prostrated him, not the punches. It made sense to him but not to others.

They dug into Graziano's army record and found he had been dishonorably discharged, and for this he was barred in Illinois and any other place capable of supporting a championship fight. They straightened him out in Washington, D.C., and all he took for his end was a dollar. He gave the rest to charity. He boxed Sonny Horne and won the decision in a one-sided fight. I told Zale that Graziano appeared to be sluggish and bewildered, and did not look as good as he should.

"If you were in there with him Monday, you would have stiffened him," I said.

"Monday or any other day," Zale said. "What difference would it make? The heat beat me the last time."

They fought the third one in the Newark ballpark. Graziano approached the calamity with the casualness of a man who has a few rounds to squander. It was obvious that he planned to hang around until Zale collapsed under the burden of his thirty-four years. But that night Zale refused to accept the penalty of pugilistic senility. Graziano put his left hand straight out and then jumped after it. It was a jab that had its origin in the ballet. He was rewarded for this clumsy impersonation of cleverness with left hooks and right crosses which landed either on the jaw or the belly. Graziano made motions with his hands which suggested that his skin had suddenly become tight on the bones of his shoulder. Before he could remedy this with calisthenics, Zale hit him with a right to the jaw. It made him back up into the ropes, and then he was hit in the belly and on the chin with swift hooks. He went down, was up at three. There was a cut on the left side of his forehead, like an Indian caste mark made by a cross-eyed tattooer. Zale did not become desperate with eagerness, and he beat up Graziano with confidence. He demolished Graziano with a methodical consistency. But deep in the second Graziano awakened and achieved a temporary fury. He snarled with a rage which did not impress Zale, but some of the punches did. There were times when Zale's legs shuddered and his head wobbled and his sallow face was sunken. The bones seemed about to break through the taut skin. During the intermission between the rounds, Art Winch, in Zale's corner, looked over at Graziano.

"If you hurt him, finish him," Winch said. "He's all in."

The hook made Graziano sink into a squat with his left arm bent over the middle rope as though it were a flabby crutch. But he struggled and regained a trembling erectness. Another left hook knocked him down. He crawled over on his belly, moving slowly, rolled over and was up at seven. He began to slide down. There was a second of indecision. He cowered there for a moment, but decided to fight. His punches were protective measures, and Zale took pots. Graziano was spent and stooped forward in a round-shouldered posture of helplessness. Zale hit him with the left hook, and Graziano went over backward. His head made the sound an auctioneer's mallet makes on a solid block of wood when the deal is closed. They came out of the corner and picked him up and put the green-edged white bathrobe over his shoulders. The green letters on the back spelled out: ROCKY GRAZIANO, MIDDLEWEIGHT CHAMPION OF THE WORLD.

Only the name was correct.

Guys like me will write a lot about Tony Zale in the years to come. We will depend on memory and probably exaggerate what he was, because that is the way guys are when they get older. It doesn't matter how many guys he licked or how many of them licked him. If you saw him the three times he fought Graziano, you know this was a champion. Graziano said it best, and he told it to me and to everyone who asked him about it after the second fight.

"There's only one way you can lick Zale," Graziano said. "You got to kill him."

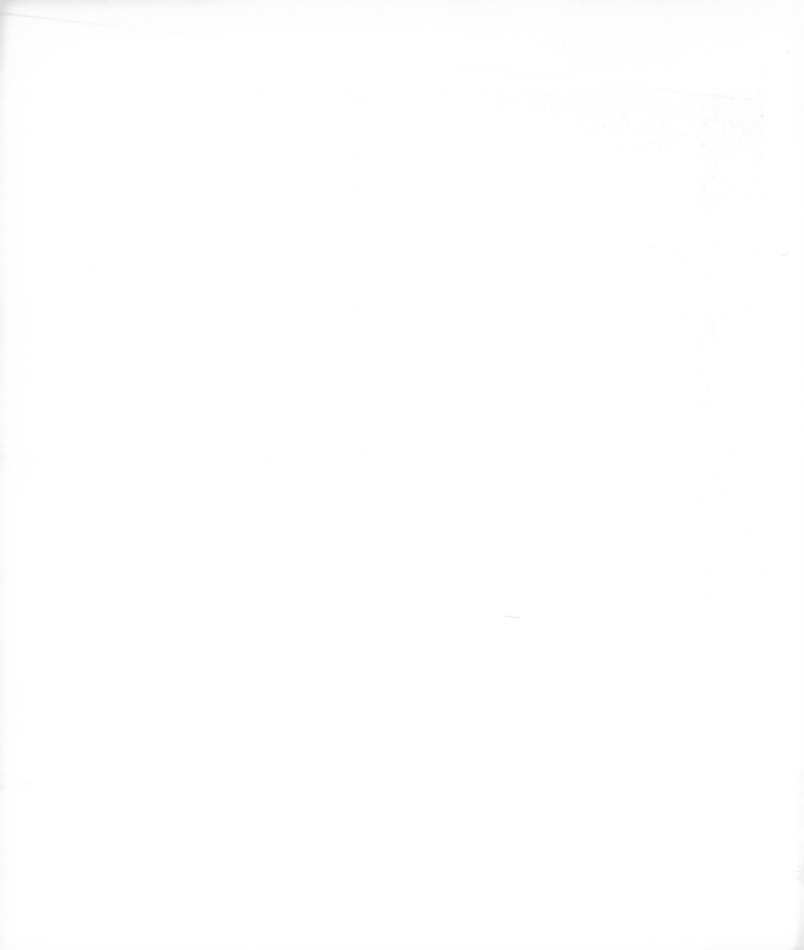

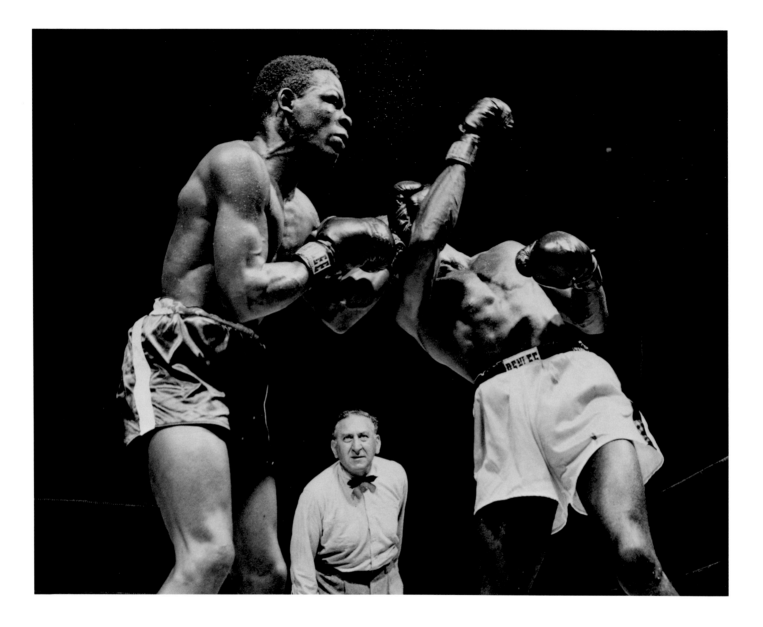

IKE WILLIAMS VS. BOB MONTGOMERY, AUGUST 4, 1947

43

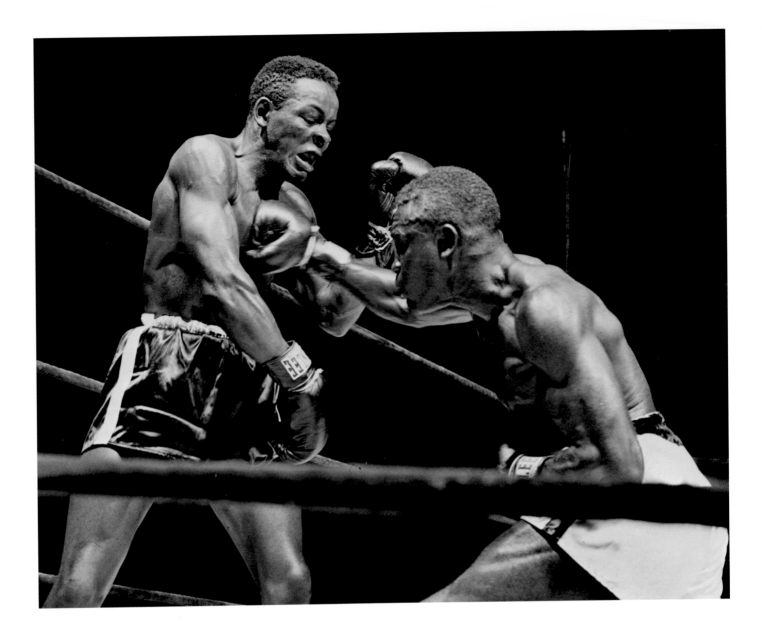

IKE WILLIAMS VS. BOB MONTGOMERY, AUGUST 4, 1947

44

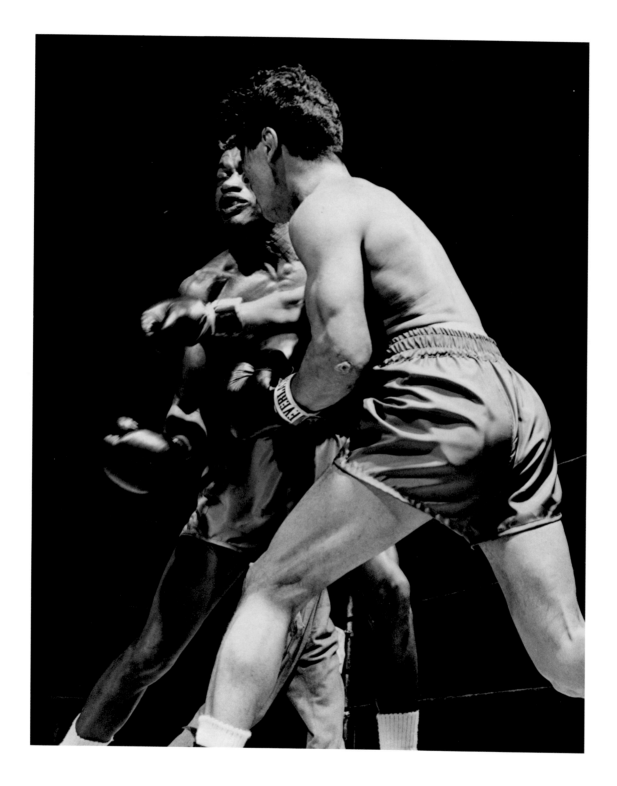

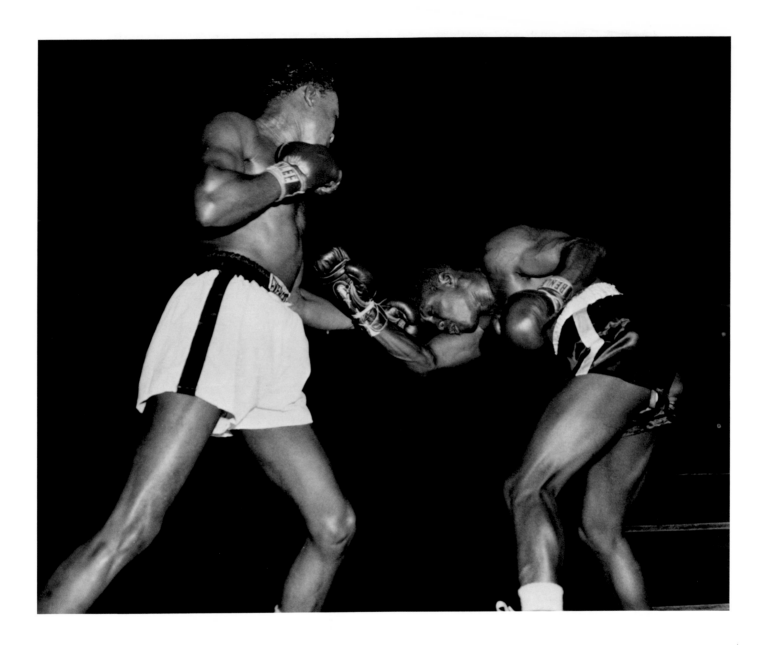

KID GAVILAN VS. JOHNNY BRATTON, MAY 18, 1951

46

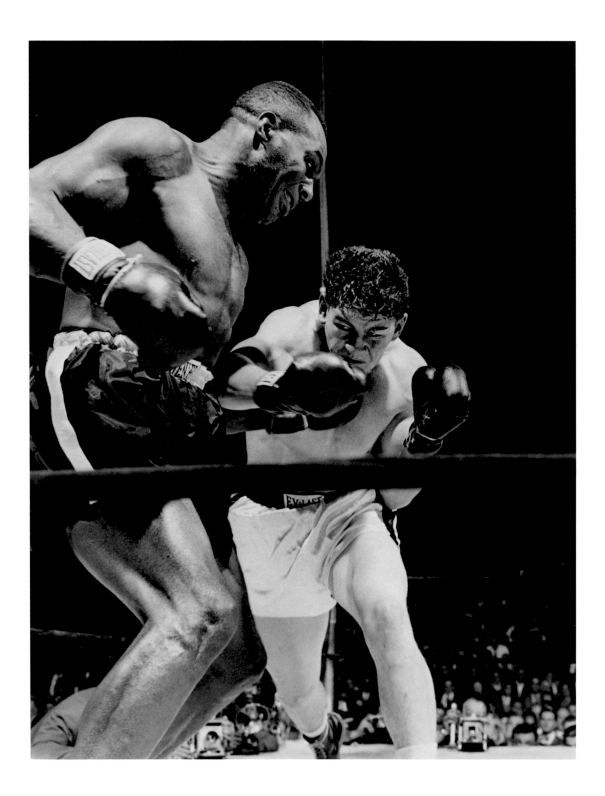

JERSEY JOE WALCOTT VS. REX LAYNE, NOVEMBER 24, 1950

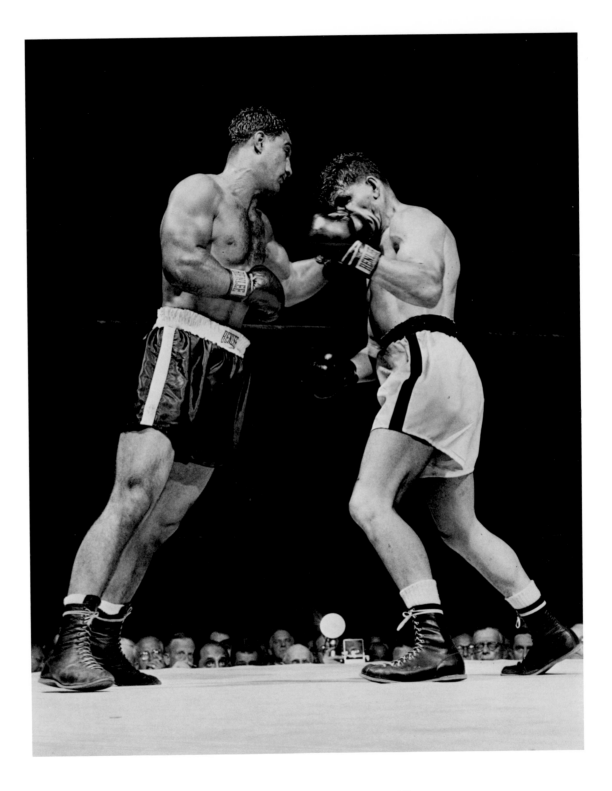

ROCKY MARCIANO VS. REX LAYNE, JULY 12, 1951

48

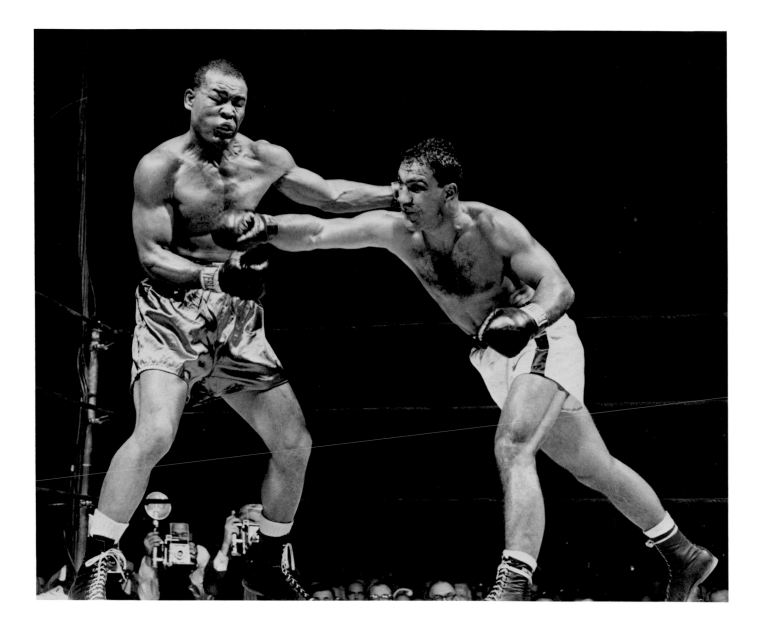

JOE LOUIS VS. ROCKY MARCIANO, OCTOBER 26, 1951

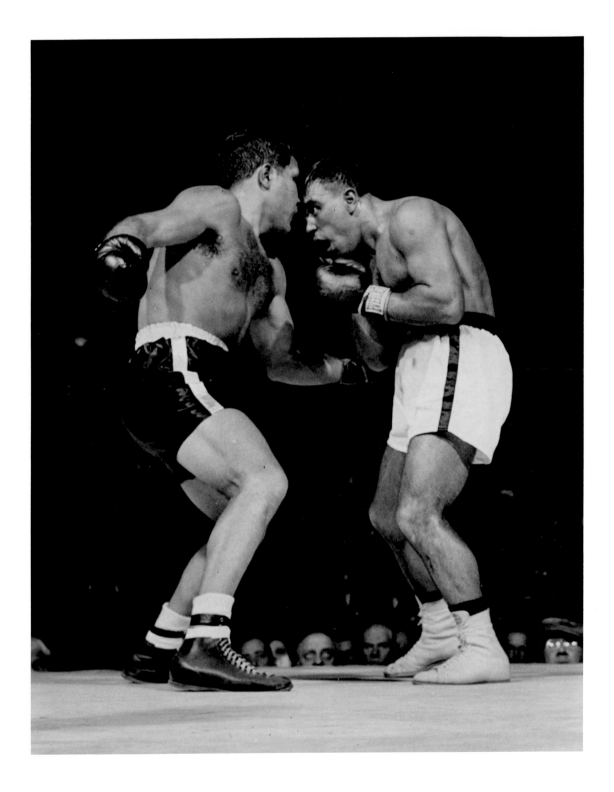

UNIDENTIFIED BOXER VS. BO BO OLSON

50

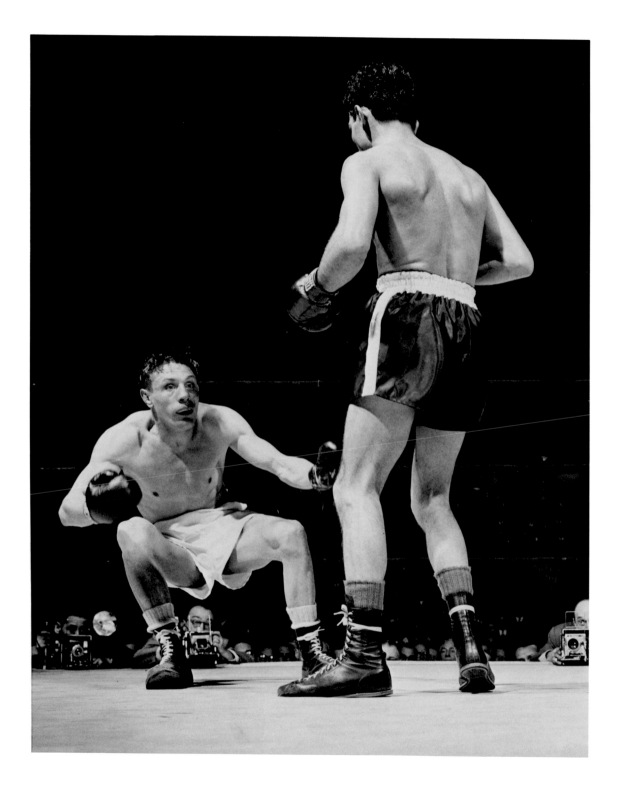

WILLIE PEPP VS. PAT MARCUNE, JUNE 5, 1953

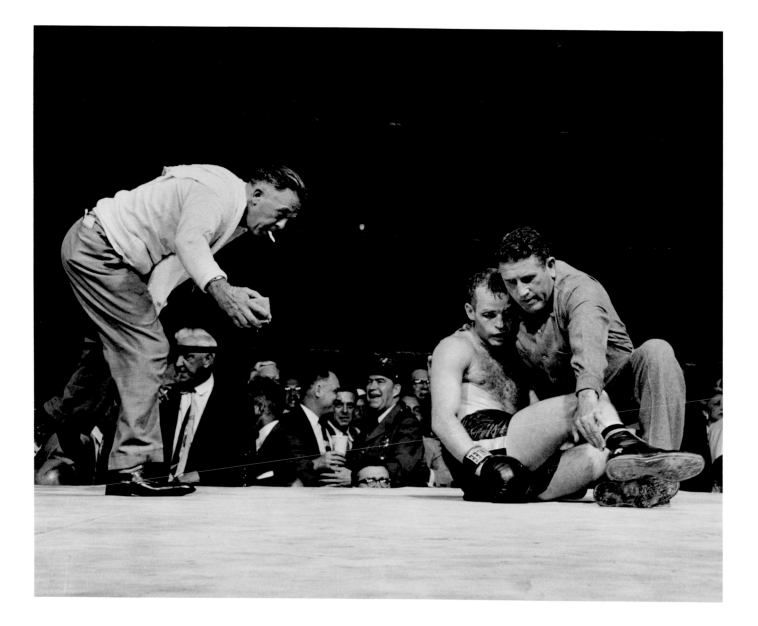

INGEMAR JOHANSSON (SHOWN) VS. FLOYD PATTERSON, JUNE 20, 1960

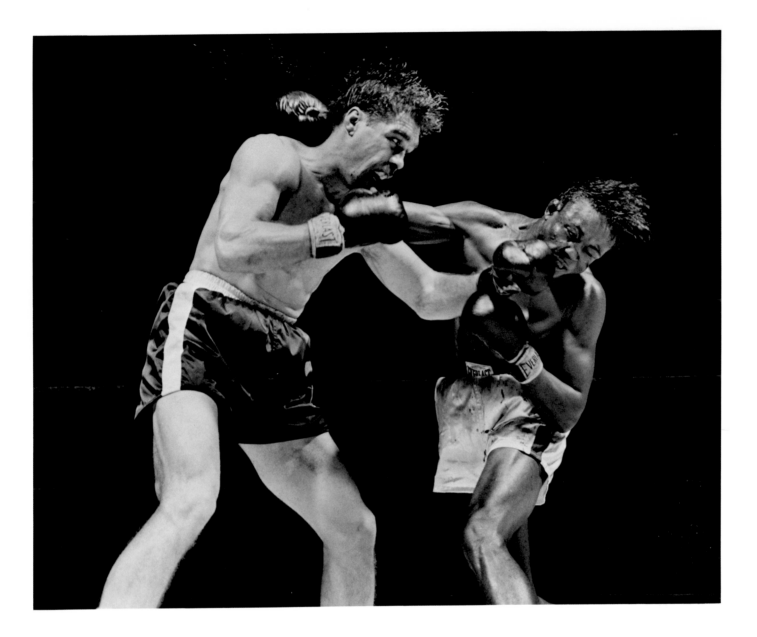

WALTER CARTIER VS. KID GAVILAN, DECEMBER 14, 1951

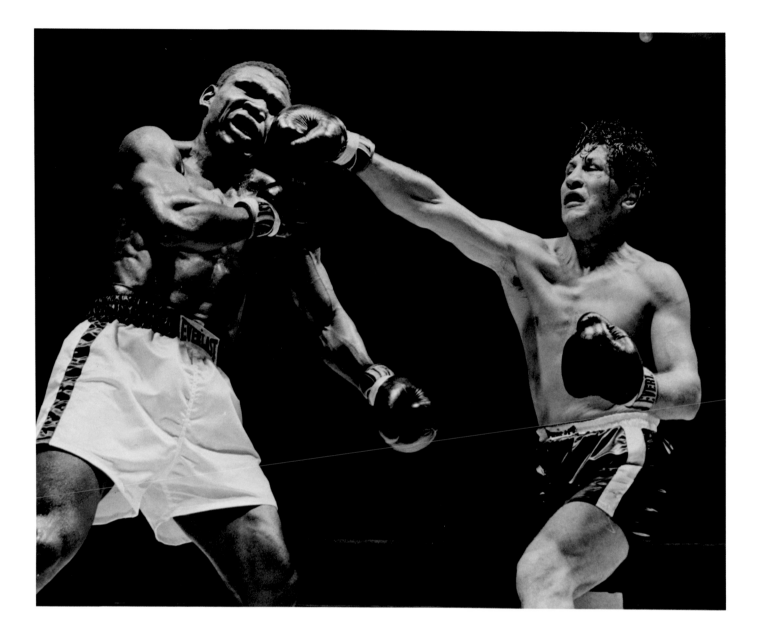

DICK TIGER VS. JOEY GIARDELLO, OCTOBER 21, 1965

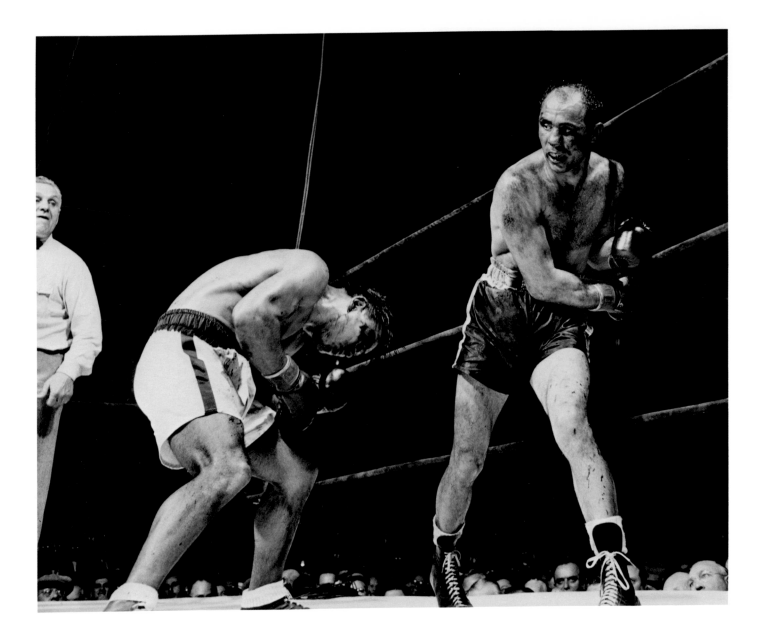

ROBERT VILLEMAIN VS. STEVE BELLOISE, JANUARY 7, 1949

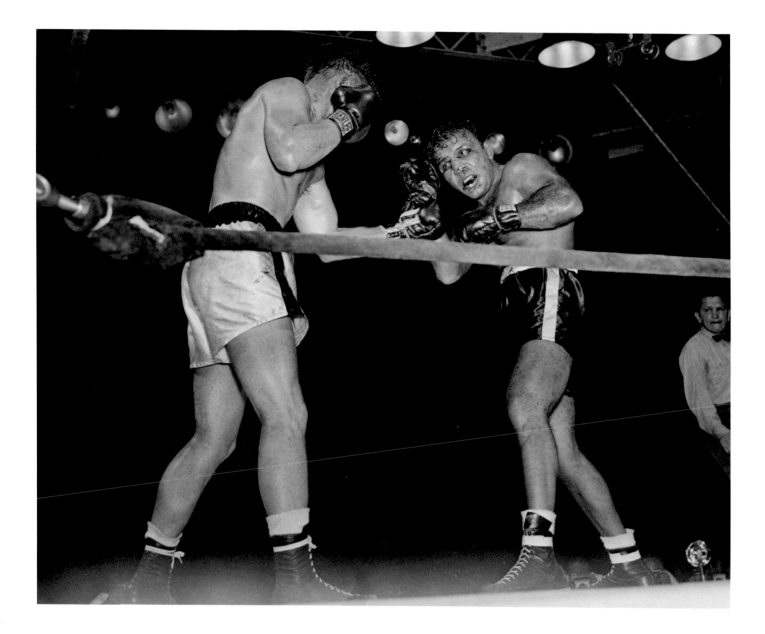

ROBERT VILLEMAIN VS. JAKE LA MOTTA, MARCH 25, 1949

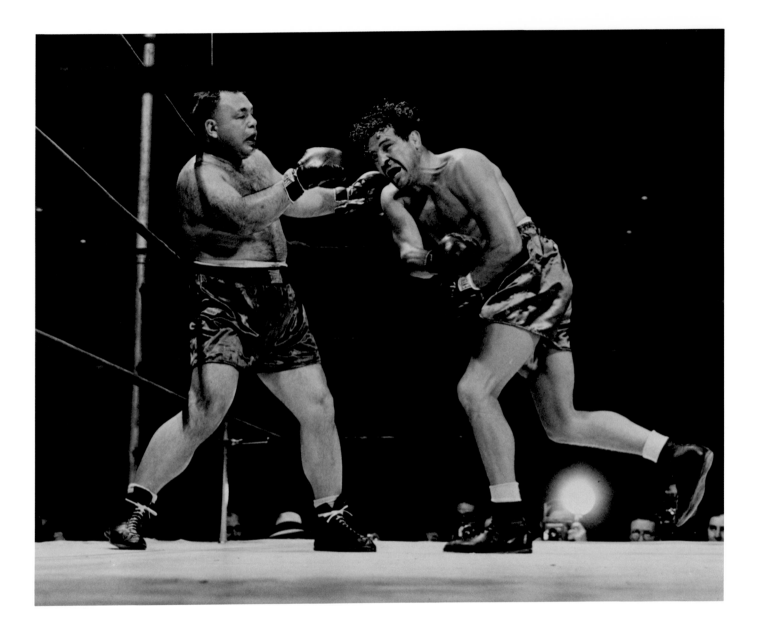

TONY GALENTO VS. MAX BAER, JULY 2, 1940

58

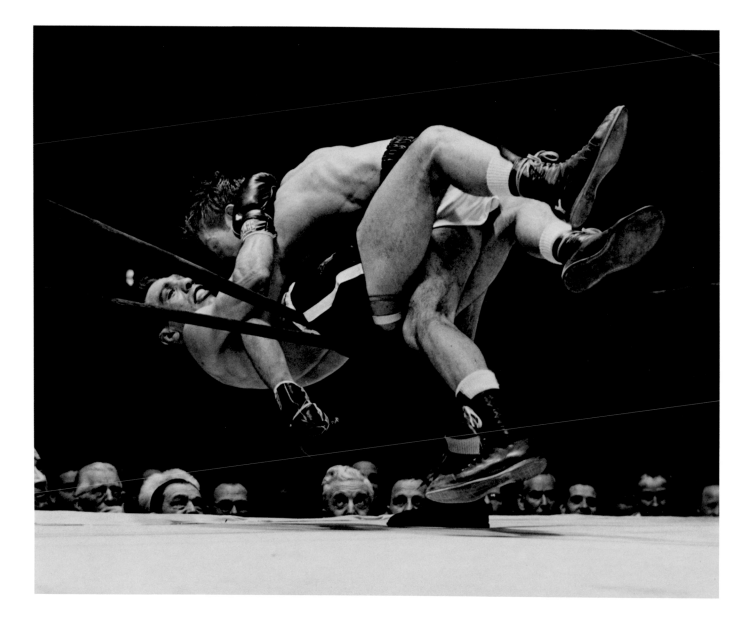

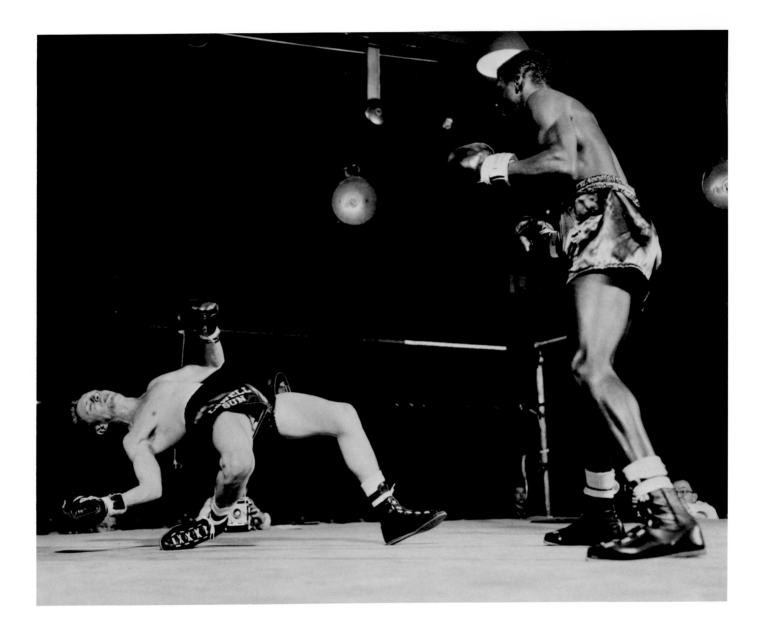

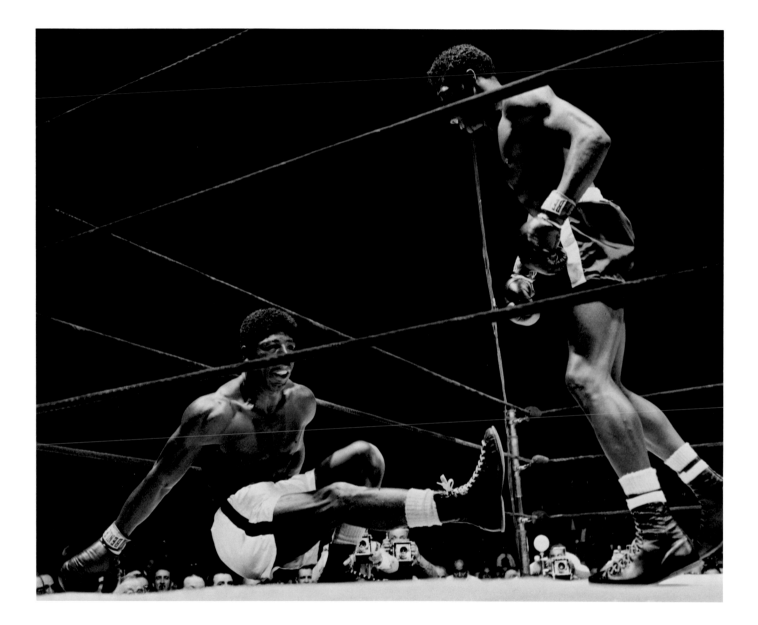

JIMMY SLADE VS. FLOYD PATTERSON, NOVEMBER 19, 1954

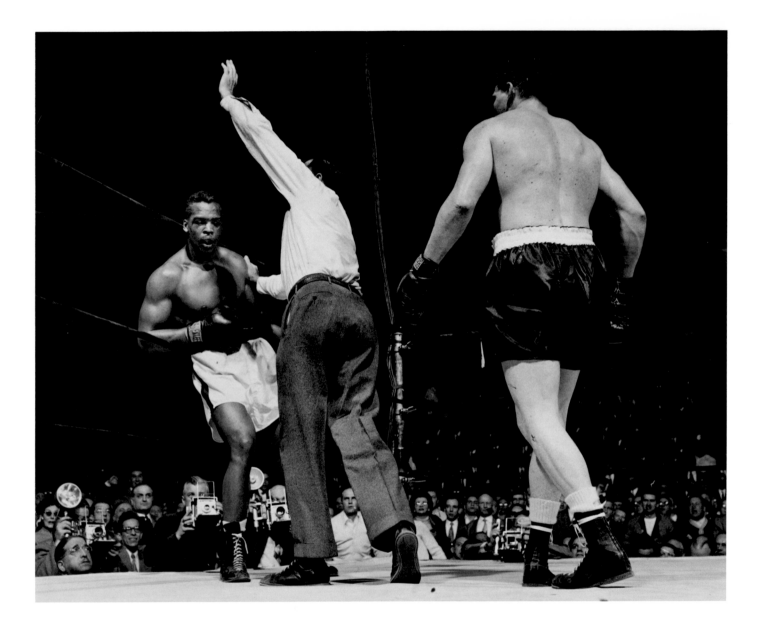

BOB SATTERFIELD VS. UNIDENTIFIED BOXER

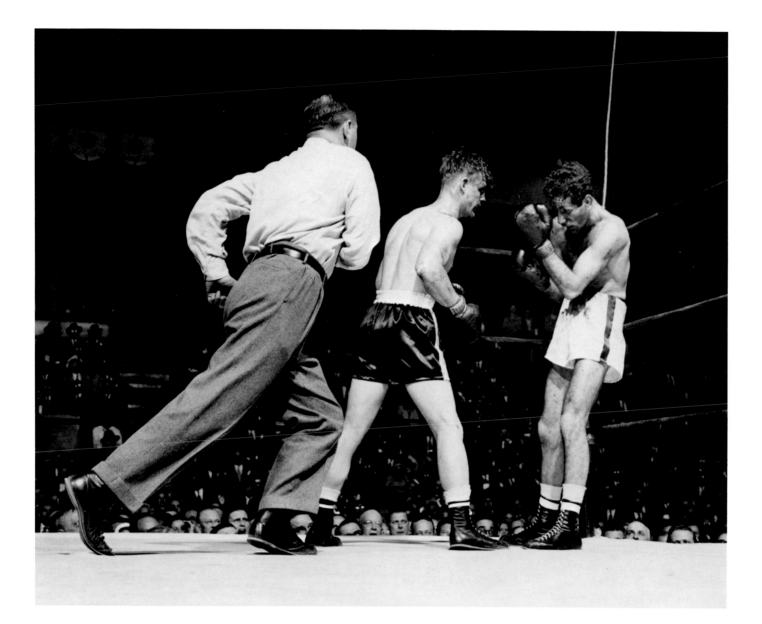

BOB MURPHY VS. DAN BUCHERONI

63

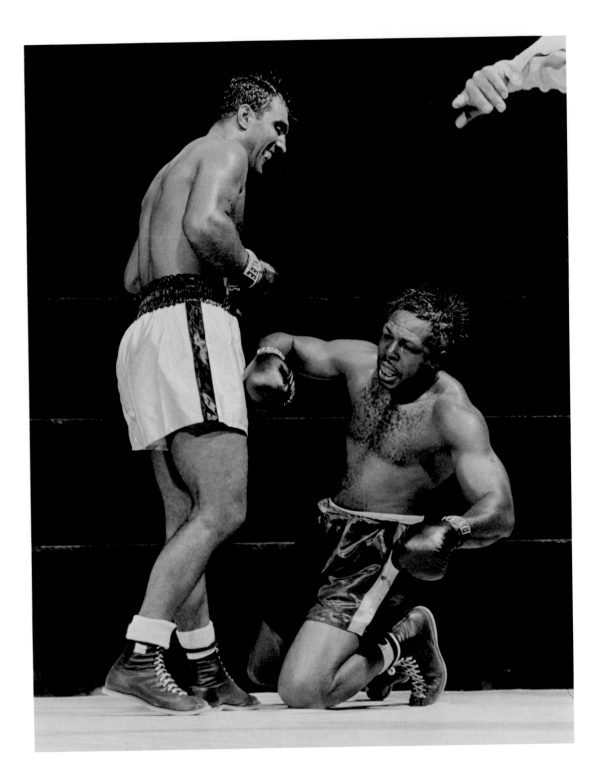

ROCKY MARCIANO VS. ARCHIE MOORE, SEPTEMBER 21, 1955

64

O UNLUCKY MAN

WILLIAM NACK

Someday they're gonna write a blues song just for fighters.
It'll be for slow guitar, soft trumpet, and a bell.

CHARLES (SONNY) LISTON

It was already dark when she stepped from the car in front of her house on Ottawa Drive, but she could see her pink Cadillac convertible and Sonny's new black Fleetwood under the carport in the Las Vegas night.

Where could Charles be? Geraldine Liston was thinking.

All through the house the lamps were lit, even around the swimming pool out back. The windows were open too, and the doors were unlocked. It was quiet except for the television playing in the room at the top of the stairs.

By 9:30 P.M. on January 5, 1971, Geraldine had not spoken to her husband for twelve days. On Christmas Eve she had called him from St. Louis after flying there with the couple's seven-year-old son, Danielle, to spend the holidays with her mother. Geraldine had tried to phone him a number of times, but no one had answered at the house. At first she figured he must be off roistering in Los Angeles, and so she didn't pay his absence any mind until the evening of December 28. That night, in a fitful sleep, she had a vision so unsettling that it awakened her and sent her to her mother's room.

"I had the worst dream," Geraldine says. "He was falling in the shower and calling my name, 'Gerry, Gerry!' I can still see it. So I got real nervous. I told my mother, 'I think something's wrong.' But my mother said, 'Oh, don't think that. He's all right.'"

In fact, Sonny Liston had not been right for a long time, and not only for the strangely dual life he had been leading—spells of choirboy abstinence squeezed between binges of drinking and

drugs—but also for the rudderless, unfocused existence he had been reduced to. Jobless and nearly broke, Liston had been moving through the murkier waters of Las Vegas's drug culture. "I knew he was hanging around with the wrong people," one of his closest friends, gambler Lem Bankier, says. "And I knew he was in desperate need of cash."

So, as the end of 1970 neared, Liston had reached that final twist in the cord. Eight years earlier he was the undisputed heavyweight champion of the world—a 6-foot-1½-inch 215-pound hulk with upper arms like picnic roasts, two magnificent 14-inch fists, and a scowl that he mounted for display on a round, otherwise impassive face. He had won the title by flattening Floyd Patterson with two punches, left hooks down and up, in the first round of their fight on September 25, 1962; ten months later he had beaten Patterson again in one round.

Liston did not sidestep his way to the title; the pirouette was not among his moves. He reached Patterson by walking through the entire heavyweight division, leaving large bodies sprawled behind him: Wayne Bethea, Mike DeJohn, Cleveland Williams, Nino Valdes, Roy Harris, Zora Folley, et al. Finally, a terrified Patterson waited for him, already fumbling with his getaway disguise, dark glasses and a beard.

Before the referee could count to ten in that first fight, Liston had become a mural-sized American myth, a larger-than-life John Henry with two hammers, an 84-inch reach, 23 knockouts (in 34 bouts), and 19 arrests. Tales of his exploits spun well with the fight crowd over beers in dark wood bars. There was the one about how he used to lift up the front end of automobiles. And one about how he caught birds with his bare hands. And another about how he hit speed bags so hard that he tore them from their hinges, and ripped into heavy bags until they burst, spilling their stuffing.

"Nobody hit those bags like Sonny," says eighty-year-old Johnny Tocco, one of Liston's first and last trainers. "He tore bags up. He could turn that hook, put everything behind it. Turn and snap. *Bam!* Why, he could knock you across the room with a jab. I saw him knock guys out with a straight jab. *Bam!* In the ring, Sonny was a killing machine."

Perhaps no fighter had ever brought to the ring so palpable an aura of menace. Liston

hammered out danger, he hammered out a warning. There was his fearsome physical presence; then there was his heavy psychic baggage, his prison record and assorted shadows from the underworld. Police in three cities virtually drove him out of town; in one of them, St. Louis, a captain warned Liston that he would wind up dead in an alley if he stayed.

In public Liston was often surly, hostile, and uncommunicative, and so he fed one of the most disconcerting of white stereotypes, that of the ignorant, angry, morally reckless Black roaming loose, with bad intentions, in white society. He became a target for racial typing in days when white commentators could still utter undisguised slurs without Ted Koppel asking them to, please, explain themselves. In the papers Liston was referred to as "a gorilla," "a latter-day caveman," and "a jungle beast." His fights against Patterson were seen as morality plays. Patterson was good, Liston was evil.

On July 24, 1963, two days after the second Patterson fight, *Los Angeles Times* columnist Jim Murray wrote: "The central fact . . . is that the world of sport now realizes it has gotten Charles (Sonny) Liston to keep. It is like finding a live bat on a string under your Christmas tree."

The NAACP had pleaded with Patterson not to fight Liston. Indeed, many Blacks watched Liston's spectacular rise with something approaching horror, as if he were climbing the Empire State Building with Fay Wray in his hands. Here, suddenly, was a baleful Black felon holding the most prestigious title in sports. This was at the precise moment in history when a young civil rights movement was emerging, a movement searching for role models. Television was showing freedom marchers being swept by fire hoses and attacked by police dogs. Yet, untouched by image makers, Liston steadfastly refused to speak any mind but his own. Asked by a young white reporter why *he* wasn't fighting for freedom in the South, Liston deadpanned, "I ain't got no dog-proof ass."

Four months after Liston won the title, *Esquire* thumbed its nose at its white readers with an unforgettable cover. On the front of its December 1963 issue, there was Liston glowering out from under a tasseled red-and-white Santa Claus hat, looking like the last man on earth America wanted to see coming down its chimney.

Now, at the end of the Christmas holiday of 1970, that old Black Santa was still missing in Las Vegas. Geraldine crossed through the carport of the Listons' split-level and headed for the patio out back. Danielle was at her side. Copies of the *Las Vegas Sun* had been gathering in the carport since December 29. Geraldine opened the back door and stepped into the den. A foul odor hung in the air, permeating the house, and so she headed up the three steps toward the kitchen. "I thought he had left some food out and it had spoiled," she says. "But I didn't see anything."

Leaving the kitchen, she walked toward the staircase. She could hear the television from the master bedroom. Geraldine and Danielle climbed the stairs and looked through the bedroom door, to the smashed bench at the foot of the bed and the stone-cold figure lying with his back up against it, blood caked on the front of his swollen shirt and his head canted to one side. She gasped and said, "Sonny's dead."

"What's wrong?" Danielle asked.

She led the boy quickly down the stairs. "Come on, baby," she said.

On the afternoon of September 27, 1962, Liston boarded a flight from Chicago to Philadelphia. He settled into a seat next to his friend Jack McKinney, an amateur fighter who was then a sports writer for the *Philadelphia Daily News*. This was the day Liston had been waiting for ever since he had first laced on boxing gloves at the Missouri State Penitentiary a decade earlier. Forty-eight hours before, he had bludgeoned Patterson to become heavyweight champion. Denied a title fight for years, barred from New York City rings as an undesirable, largely ignored in his adopted Philadelphia, Liston suddenly felt vindicated, redeemed. In fact, before leaving the Sheraton Hotel in Chicago, he had received word from friends that the people of Philadelphia were awaiting his triumphant return with a ticker tape parade.

The only disquieting tremor had been some other news out of Philadelphia, relayed to him by telephone from friends back home, that *Daily News* sports editor Larry Merchant had written a column confirming Liston's worst fears about how his triumph might be received.

Those fears were based on the ruckus that had preceded the fight. The *New York Times*'s Arthur Daley had led the way: "Whether Patterson likes it or not, he's stuck with it. He's the knight in shining armor battling the forces of evil."

Now wrote Merchant: "So it is true—in a fair fight between good and evil, evil must win. . . . A celebration for Philadelphia's first heavyweight champ is now in order. Emily Post probably would recommend a ticker-tape parade. For confetti we can use shredded warrants of arrest."

The darkest corner of Liston's personality was his lack of a sense of self. All the signs from his past pointed the same way and said the same thing: dead end. He was the twenty-fourth of the twenty-five children fathered by Tobey Liston, a tenant cotton farmer who lived outside Forrest City, Arkansas. Tobey had two families, one with fifteen children and the other with ten; Charles was born ninth to his mother, Helen. Outside the ring, he battled his whole life against writers who suggested that he was older than he claimed he was. "Maybe they think I'm so old because I never was really young," he said. Usually, he would insist he was born on May 8, 1932, in the belly of the Great Depression, and he growled at reporters who dared to doubt him on this: "Anybody who says I'm not thirty is callin' my momma a liar."

"Sonny was so sensitive on the issue of his age because he did not really *know* how old he was," says McKinney. "When guys would write that he was thirty-two going on fifty, it had more of an impact on him than anybody realized. Sonny did not know *who* he was. He was looking for an identity, and he thought that being the champion would give him one."

Now that moment had arrived. During the flight home, McKinney says, Liston practiced the speech he was going to give when the crowds greeted him at the airport. Says McKinney, who took notes during the flight, "He used me as sort of a test auditor, dry-running his ideas by me."

Liston was excited, emotional, eager to begin his reign. "There's a lot of things I'm gonna do," he told McKinney. "But one thing's very important: *I want to reach my people.* I want to reach them and tell them, 'You don't have to worry about me disgracin' you. You won't have to worry about me stoppin' your progress.' I want to go to colored churches and colored neighborhoods. I know it was in the papers that the better class of colored people were hopin' I'd lose, even prayin'

I'd lose, because they was afraid I wouldn't know how to act. . . . I remember one thing so clear about listening to Joe Louis fight on the radio when I was a kid. I never remember a fight the announcer didn't say about Louis, 'A great fighter and a credit to his race.' Remember? That used to make me feel real proud inside.

"I don't mean to be sayin' I'm just gonna be the champion of my own people," Liston continued. "It sayin' now I'm the world's champion, and that's just the way it's gonna be. I want to go to a lot of places—like orphan homes and reform schools. I'll be able to say, 'Kid, I know it's tough for you and it might even get tougher. But don't give up on the world. Good things can happen if you let them.'"

Liston was ready. As the plane rolled to a stop, he rose and walked to the door. McKinney was next to him. The staircase was wheeled to the door. Liston straightened his tie and his fedora. The door opened, and he stepped outside. There was no one there except for airline workers, a few reporters and photographers, and a handful of PR men. "Other than those, no one," recalls McKinney. "I watched Sonny. His eyes swept the whole scene. He was extremely intelligent, and he understood immediately what it meant. His Adam's apple moved slightly. You could feel the deflation, see the look of hurt in his eyes. It was almost like a silent shudder went through him. He'd been deliberately snubbed.

"Philadelphia wanted nothing to do with him. Sonny felt, after he won the title, that the past was forgiven. It was going to be a whole new world. What happened in Philadelphia that day was a turning point in his life. He was still the bad guy. He was the personification of evil. And that's the way it was going to remain. He was devastated. I knew from that point on that the world would never get to know the Sonny that I knew."

On the way out of the airport after a brief press conference, Sonny turned to McKinney and said, "I think I'll go out tomorrow and do all the things I've always done. Walk down the block and buy the papers, stop in the drugstore, talk to the neighbors. Then I'll see how the *real peoples* feel. Maybe then I'll start to feelin' like a champion. You know, it's really a lot like an election, only in reverse. Here I'm already in office, but now I have to go out and start campaignin'."

That was a campaign that Liston could never win. He was to be forever cast in the role of devil's agent, and never more so than in his two stunning, ignominious losses to Cassius Clay, then beginning to be known as Muhammad Ali. In the history of boxing's heavyweight division, never has a fighter fallen faster, and farther, than did Liston in the fifteen months it took Ali to reduce him from being the man known as the fiercest alive to being the butt of jokes on TV talk shows.

"I think he died the day he was born," wrote Harold Conrad, who did publicity for four of Liston's fights. By the nearest reckoning, that birth would have been in a tenant's shack, seventeen miles northwest of Forrest City and about sixty west of Memphis. Helen had met Tobey in Mississippi and had gone with him to Arkansas around the time of World War I. Charles grew up lost among all the callused hands and bare feet of innumerable siblings. "I had nothing when I was a kid but a lot of brothers and sisters, a helpless mother, and a father who didn't care about any of us," Liston said. "We grew up with few clothes, no shoes, little to eat. My father worked me hard and whupped me hard."

Helen moved to St. Louis during World War II, and Charles, who was living with his father, set out north to find her when he was thirteen. Three years later he weighed two hundred pounds, and he ruled his St. Louis neighborhood by force. At eighteen, he had already served time in a house of detention and was graduating to armed robbery. On January 15, 1950, Liston was found guilty of two counts of larceny from a person and two counts of first-degree robbery. He served more than two years in the Missouri State Pen in Jefferson City.

The prison's athletic director, Father Alois Stevens, a Catholic priest, first saw Liston when he came by the gym to join the boxing program. To Stevens, Liston looked like something out of Jane's Fighting Ships. "He was the most perfect specimen of manhood I had ever seen," Stevens recalls. "Powerful arms, big shoulders. Pretty soon he was knocking out everybody in the gym. His hands were so large! I couldn't believe it. They always had trouble with his gloves, trouble getting them on when his hands were wrapped."

In 1952 Liston was released on parole, and he turned pro on September 2, 1953, leveling Don Smith in the first round in St. Louis. Tocco met Liston when the fighter strolled into Tocco's gym in St. Louis. The trainer's first memory of Liston is fixed, mostly for the way he came in—slow and deliberate and alone, feeling his way along the edges of the gym, keeping to himself, saying nothing. That was classic Liston, casing every joint he walked into, checking for exits. As Liston began to work, Tocco saw the bird tracks up and down Liston's back, the enduring message from Tobey Liston.

"What are all those welts from?" Tocco asked him.

Said Liston, "I had bad dealin's with my father."

"He was a loner," Tocco says. "He wouldn't talk to nobody. He wouldn't go with nobody. He always came to the gym by himself. He always left by himself. The police knew he'd been in prison, and he'd be walking along and they'd always stop him and search him. So he went through alleys all the time. *He always went around things.* I can still see him, either coming out of an alley or walking into one."

Nothing was simpler for Liston to fathom than the world between the ropes—step, jab, hook—and nothing more unyielding than the secrets of living outside them. He was a mob fighter right out of prison. One of his managers, Frank Mitchell, the publisher of the *St. Louis Argus,* who had been arrested numerous times on suspicion of gambling, was a known front for John Vitale, St. Louis's reigning hoodlum. Vitale had ties to organized crime's two most notorious boxing manipulators: Frankie Carbo and Carbo's lieutenant, Frank "Blinky" Palermo, who controlled mob fighters out of Philadelphia. Vitale was in the construction business (among others), and when Liston wasn't fighting, one of his jobs was cracking heads and keeping Black laborers in line. Liston always publicly denied this, but years later he confided his role to one of his closest Las Vegas friends, Davey Pearl, a boxing referee. "He told me that when he was in St. Louis, he worked as a labor goon," says Pearl, "breaking up strikes."

Not pleased with the company Liston was keeping—one of his pals was 385-pound Barney Baker, a reputed head cracker for the teamsters—the St. Louis police kept stopping Liston, on

sight and without cause, until, on May 5, 1956, 3½ years after his release from prison, Liston assaulted a St. Louis policeman, took his gun, left the cop lying in an alley, and hid the weapon at a sister's house. The officer suffered a broken knee and a gashed face. The following December, Liston began serving nine months in the city workhouse.

Soon after his release Liston had his second run-in with a St. Louis cop. The officer had creased Liston's skull with a nightstick, and two weeks later the fighter returned the favor by depositing the fellow headfirst in a trash can. Liston then fled St. Louis for Philadelphia, where Palermo installed one of his pals, Joseph "Pep" Barone, as Liston's manager, and Liston at once began fighting the biggest toughs in the division. He stopped Bethea, who spit out seven teeth, in the first round. Valdes fell in three, and so did Williams. Harris swooned in one, and Folley fell like a tree in three. Eddie Machen ran for twelve rounds but lost the decision. Albert Westphal keeled in one. Now Liston had one final fight to win. Only Patterson stood between him and the title.

Whether or not Patterson should deign to fight the ex-con led, at the time, to a weighty moral debate among the nation's reigning sages of sport. What sharpened the lines were Liston's recurring problems with the law in Philadelphia, including a variety of charges stemming from a June 1961 incident in Fairmount Park. Liston and a companion had been arrested for stopping a female motorist after dark and shining a light in her car. All charges, including impersonating a police officer, were eventually dropped. A month before, Liston had been brought in for loitering on a street corner. That charge, too, was dropped. More damaging were revelations that he was, indeed, a mob fighter, with a labor goon's history. In 1960, when Liston was the number one heavyweight contender, testimony before a U.S. Senate subcommittee probing underworld control of boxing revealed that Carbo and Palermo together owned a majority interest in him. Of this, Liston said, he knew nothing. "Pep Barone handles me," he said.

"Do you think that people like [Carbo and Palermo] ought to remain in the sport of boxing?" asked the committee chairman, Tennessee Senator Estes Kefauver.

"I wouldn't pass judgment on no one," Liston replied. "I haven't been perfect myself."

In an act of public cleansing after the Fairmount Park incident, Liston spent three months living in a house belonging to the Loyola Catholic Church in Denver, where he had met Father Edward Murphy, a Jesuit priest, while training to fight Folley in 1960. Murphy, who died in 1975, became Liston's spiritual counselor and teacher. "Murph gave him a house to live in and tried to get him to stop drinking," Father Thomas Kelly, one of Murphy's closest friends, recalls. "That was his biggest problem. You could smell him in the mornings. Oh, poor Sonny. He was just an accident waiting to happen. Murph used to say, 'Pray for the poor bastard.'"

But even Liston's sojourn in Denver didn't still the debate over his worthiness to fight for the title. In this bout between good and evil, the clearest voice belonged to *New York Herald Tribune* columnist Red Smith: "Should a man with a record of violent crime be given a chance to become champion of the world? Is America less sinful today than in 1853 when John Morrissey, a saloon brawler and political head breaker out of Troy, N.Y., fought Yankee Sullivan, lamster from the Australian penal colony in Botany Bay? In our time, hoodlums have held championships with distinction. Boxing may be purer since their departure; it is not healthier."

Since he could not read, Liston missed many pearls, but friends read scores of columns to him. When Barone was under fire for his mob ties, Liston quipped, "I got to get me a manager that's not hot—like Estes Kefauver." Instead, he got George Katz, who quickly came to appreciate Liston's droll sense of humor. Katz managed Liston for ten percent of his purses, and as the two sat in court at Liston's hearing for the Fairmount Park incident, Liston leaned over to Katz and said, "If I get time, you're entitled to ten percent of it."

Liston was far from the sullen, insensitive brute of popular imagination. Liston and McKinney would take long walks between workouts, and during them Liston would recite the complete dialogue and sound effects of the comedy routines of Black comedians like Pigmeat Markham and Redd Foxx. "He could imitate what he heard down to creaking doors and women's voices," says McKinney. "It was hilarious hearing him do falsetto."

Liston also fabricated quaint metaphors to describe phenomena ranging from brain damage to the effects of his jab: "The middle of a fighter's forehead is like a dog's tail. Cut off the tail

and the dog goes all whichway 'cause he ain't got no more balance. It's the same with a fighter's forehead."

He lectured occasionally on the unconscious, though not in the Freudian sense. Setting the knuckles of one fist into grooves between the knuckles of the other fist, he would explain: "See, the different parts of the brain set in little cups like this. When you get hit a terrible shot—*pop!*— the brain settles back in the cups and you come to. But after this happens enough times, or sometimes even once if the shot's hard enough, the brain don't settle back right in them cups, and that's when you start needing other people to help you get around."

So it was that Liston vowed to hit Patterson on the dog's tail until his brain flopped out of its cups. Actually, he missed the tail and hit the chin. Patterson was gone. Liston had trained to the minute, and he would never again be as good a fighter as he was that night. For what? Obviously, nothing in his life had changed. He left Philadelphia after he won the title, because he believed he was being harassed by the police of Fairmount Park, through which he had to drive to get from the gym to his home. At one point he was stopped for "driving too slow" through the park. That did it. In 1963 he moved to Denver, where he announced, "I'd rather be a lamppost in Denver than the mayor of Philadelphia."

At times, in fact, things were not much better in the Rockies. "For a while the Denver police pulled him over every day," says Ray Schoeninger, a former Liston sparring partner. "They must have stopped him a hundred times outside City Park. He'd run on the golf course, and as he left in his car, they'd stop him. Twenty-five days in a row. Same two cops. They thought it was a big joke. It made me ashamed of being a Denver native. Sad they never let him live in peace."

Liston's disputes were not always with the police. After he had won the title, he walked into the dining room of the Beverly Rodeo Hotel in Hollywood and approached the table at which former rumrunner Moe Dalitz, head of the Desert Inn in Las Vegas and a boss of the old Cleveland mob, was eating. The two men spoke. Liston made a fist and cocked it. Speaking very distinctly, Dalitz said, "If you hit me, nigger, you'd better kill me. Because if you don't, I'll make one telephone call, and you'll be dead in twenty-four hours." Liston wheeled and left.

The police and Dalitz were hardly Liston's only tormentors. There was a new and even more inescapable disturber of his peace: the boisterous Clay. Not that Liston at first took notice. After clubbing Patterson, he took no one seriously. He hardly trained for the rematch in Las Vegas. Clay, who hung around Liston's gym while the champion went through the motions of preparing for Patterson, heckled him relentlessly. Already a minor poet, Clay would yell at Liston, "Sonny is a fatty. I'm gonna whip him like his daddy!" One afternoon he rushed up to Liston, pointed to him and shouted, "He ain't whipped nobody! Who's he whipped?" Liston, sitting down, patted a leg and said, "Little boy, come sit in my lap." But Clay wouldn't sit; he was too busy running around and bellowing, "The beast is on the run!"

Liston spotted Clay one day in the Thunderbird Casino, walked up behind him and tapped him on the shoulder. Clay turned and Liston cuffed him hard with the back of his hand. The place went silent. Young Clay looked frightened. "What you do that for?" he said.

"'Cause you're too ———— fresh," Liston said. As he headed out of the casino, he said, "I got the punk's heart now."

That incident would be decisive in determining the outcome of the first Liston-Clay fight, seven months later. "Sonny had no respect for Clay after that," McKinney says. "Sonny thought all he had to do was take off his robe and Clay would faint. He made this colossal misjudgment. He didn't train at all."

If he had no respect for Clay, Liston was like a child around the radio hero of his boyhood, Joe Louis. When George Lois, then an art director at *Esquire*, decided to try the Black Santa cover, he asked his friend Louis to approach Liston. Liston grudgingly agreed to do the shoot in Las Vegas. Photographer Carl Fischer snapped one photograph, whereupon Liston rose, took off the cap and said, "That's it." He started out the door. Lois grabbed Liston's arm. The fighter stopped and stared at the art director. "I let his arm go," Lois recalls.

While Liston returned to the craps tables, Lois was in a panic. "One picture!" Lois says. "You need to take fifty, a hundred pictures to make sure you get it right." He ran to Louis, who

understood Lois's dilemma. Louis found Liston shooting craps, walked up behind him, reached up, grabbed him by an ear, and marched him out of the casino. Bent over like a puppy on a leash, Liston followed Louis to the elevator, with Louis muttering, "Come on, git!" The cover shoot resumed.

A few months later, of course, Clay handled Liston almost as easily. Liston stalked and chased, but Clay was too quick and too fit for him. By the end of the third round Liston knew that his title was in peril, and he grew desperate. One of Liston's trainers, Joe Pollino, confessed to McKinney years later that Liston ordered him to rub an astringent compound on his gloves before the fourth round. Pollino complied. Liston shoved his gloves into Clay's face in the fourth, and the challenger's eyes began burning and tearing so severely that he could not see. In his corner, before the fifth round, Clay told his handlers that he could not go on. His trainer, Angelo Dundee, had to literally push him into the ring. Moving backward faster than Liston moved forward, Clay ducked and dodged as Liston lunged after him. He survived the round.

By the sixth, Clay could see clearly again, and as he danced and jabbed, hitting Liston at will, the champion appeared to age three years in three minutes. At the end of that round, bleeding and exhausted, he could foresee his humiliating end. His left shoulder had been injured—he could no longer throw an effective punch with it—and so he stayed on his stool, just sat there at the bell to start round seven.

There were cries that Liston had thrown the fight. That night Conrad, Liston's publicist, went to see him in his room, where Liston was sitting in bed, drinking.

"What are they sayin' about the fight?" Liston asked.

"That you took a dive," said Conrad.

Liston raged. "Me? Sell my title? Those dirty bastards!" He threw his glass and shattered it against the wall.

The charges of a fix in that fight were nothing compared with what would be said about the rematch, in Lewiston, Maine, during which Liston solidified his place in boxing history. Ali, as the

young champion was now widely called, threw one blow, an overhand right so dubious that it became known as the Phantom Punch, and suddenly Liston was on his back. The crowd came to its feet in anger, yelling, "Fake! Fake!"

Ali looked down at the fallen Liston, cocked a fist and screamed, "Get up and fight, sucker! Get up and fight!"

There was chaos. Referee Joe Walcott, having vainly tried to push Ali to a neutral corner, did not start a count, and Liston lay there unwilling to rise. "Clay caught me cold," Liston would recall. "Anybody can get caught in the first round, before you work up a sweat. Clay stood over me. I never blacked out. But I wasn't gonna get up, either, not with him standin' over me. See, you can't get up without puttin' one hand on the floor, and so I couldn't protect myself."

The finish was as ugly as a Maine lobster. Walcott finally moved Ali back, and as Liston rose, Walcott wiped off his gloves and stepped away. Ali and Liston resumed fighting. Immediately, Nat Fleischer, editor of the *Ring* magazine, who was sitting next to the official timer, began shouting for Walcott to stop the fight. Liston had been down for seventeen seconds, and Fleischer, who had no actual authority at ringside, thought the fight should have been declared over. Walcott left the two men fighting and walked over to confer with Fleischer. Though he had never even started a count, Walcott then turned back to the fighters, and incredibly, stepped between them to end the fight. "I was never counted out," Liston said later. "I coulda got up *right* after I was hit."

No one believed him, of course, and even Geraldine had her doubts. Ted King, one of Liston's seconds, recalls her angrily accusing Sonny later that night of going in the water.

"You could have gotten up and you stayed down!" she cried.

Liston looked pleadingly at King. "Tell her, Teddy," he said, "Tell her I got hit."

Some who were at ringside that night, and others who have studied the films, insist that Ali indeed connected with a shattering right. But Liston's performance in Lewiston has long been perceived as a tank job, and not a convincing one at that. One of Liston's assistant trainers claims that Liston threw the fight for fear of being murdered. King now says that two well-dressed Black

Muslims showed up in Maine before the fight—Ali had just become a Muslim—and warned Liston, "You get killed if you win." So, according to King, Liston chose a safer ending. It seems fitting somehow that Liston should spend the last moments of the best years of his life on his back while the crowd showered him with howls of execration. Liston's two losses to Ali ended the short, unhappy reign of the most feared—and the most relentlessly hounded—prizefighter of his time.

Liston never really retired from the ring. After two years of fighting pushovers in Europe, he returned to the United States and began a comeback of sorts in 1968. He knocked out all seven of his opponents that year and won three more matches in 1969 before an old sparring partner, Leotis Martin, stopped him in the ninth round of a bout on December 6. That killed any chance at a title shot. On June 29, 1970, he fought Chuck Wepner in Jersey City. Tocco, Liston's old trainer from the early St. Louis days, prepared him for the fight against the man known as the Bayonne Bleeder. Liston hammered Wepner with jabs, and in the sixth round Tocco began pleading with the referee to stop the fight. "It was like blood was coming out of a hydrant," says Tocco. The referee stopped the bout in the tenth; Wepner needed fifty-seven stitches to close his face.

That was Liston's last fight. He earned $13,000 for it, but he would end up broke nonetheless. Several weeks earlier, Liston had asked Banker to place a $10,000 bet for him on undefeated heavyweight contender Mac Foster to whip veteran Jerry Quarry. Quarry stopped Foster in the sixth round, and Liston promised Banker he would pay him back after the Wepner fight. When Liston and Banker boarded the flight back to Las Vegas, Liston opened a brown paper bag, carefully counted out $10,000 in small bills and handed the wad to Banker. "He gave the other $3,000 to guys in his corner," Banker said. "That left him with nothing."

In the last weeks of his life Liston was moving with a fast crowd. At one point a Las Vegas sheriff warned Banker, through a mutual friend, to stay away from Liston. "We're looking into a drug deal," said the sheriff. "Liston is getting involved with the wrong people." At about the same time two Las Vegas policemen stopped by the gym and told Tocco that Liston had recently turned up at a house that would be the target of a drug raid. Says Tocco, "For a week the police were parked in a lot across the street, watching when Sonny came and who he left with."

On the night Geraldine found his body, Liston had been dead at least six days, and an autopsy revealed traces of morphine and codeine of a type produced by the breakdown of heroin in the body. His body was so decomposed that tests were inconclusive—officially, he died of lung congestion and heart failure—but circumstantial evidence suggests that he died of a heroin overdose. There were fresh needle marks on one of his arms. An investigating officer, Sergeant Gary Beckwith, found a small amount of marijuana along with heroin and a syringe in the house.

Geraldine, Banker, and Pearl all say that they had no knowledge of Liston's involvement with drugs, but law enforcement officials say they have reason to believe that Liston was a regular heroin user. It is possible that those closest to him may not have known of his drug use. Liston had apparently lived two lives for years.

Pearl was always hearing reports of Liston's drinking binges, but Liston was a teetotaler around Pearl. "I never saw Sonny take a drink," says Pearl. "Ever. And I was with him hundreds of times over the last five years of his life. He'd leave me at night, and the next morning someone would say to me, 'You should have seen your boy, Liston, last night. Was he ever drunk!' I once asked him, 'What is this? You leave me at night and go out and get drunk?' He just looked at me. I never, ever suspected him of doing dope. I'm telling you, I don't think he did."

Some police officials and not a few old friends think that Liston may have been murdered, though they have no way of proving it now. Conrad believes that Liston became deeply involved in a loan-sharking ring in Las Vegas as a bill collector and that he tried to muscle in for a bigger share of the action. His employers got him drunk, Conrad surmises, took him home and stuck him with a needle. There are police in Las Vegas who say they believe—but are unable to prove—that Liston was the target of a hit ordered by Ash Resnick, an old associate of Liston's with whom the former champion was having a dispute over money. Resnick died two years ago.

Geraldine has trouble comprehending all that talk about heroin or murder. "If he was killed, I don't know who would do it," she says. "If he was doing drugs, he didn't act like he was drugged. Sonny wasn't on dope. He had high blood pressure, and he had been out drinking in late December. As far as I'm concerned, he had a heart attack. Case closed."

There is no persuasive explanation of how Liston died, so the speculation continues, perhaps to last forever.

Liston is buried in Paradise Memorial Gardens, in Las Vegas, directly under the flight path for planes approaching McCarran International Airport. The brass plate on the grave is tarnished now, but the epitaph is clear under his name and the years of his life. It reads simply: A MAN. Twenty years ago Father Murphy flew in from Denver to give the eulogy, then went home and wept for an hour before he could compose himself enough to tell Father Kelly about the funeral. "They had the funeral procession down the Strip," Murphy said. "Can you imagine that? People came out of the hotels to watch him pass. They stopped everything. They used him all his life. They were still using him on the way to the cemetery. There he was, another Las Vegas show. God help us."

In the end, it seemed fitting that Liston, after all those years, would finally play to a friendly crowd on the way to his own burial—with a police escort, the most ironic touch of all.

Geraldine remained in Las Vegas for nine years after Sonny died—she was a casino hostess—then returned to St. Louis, where she had met Sonny after his parole, when he was working in a munitions factory. She has never remarried, and today works as a medical technician. "He was a great guy, great with me, great with kids, a gentle man," says Geraldine.

With Geraldine gone from Las Vegas, few visit Sonny's grave anymore. Every couple of minutes a plane roars over, shaking the earth and rattling the broken plastic flowers that someone placed in the metal urn atop his headstone. "Every once in a while someone comes by and asks to see where he's buried," says a cemetery worker, "But not many anymore. Not often."

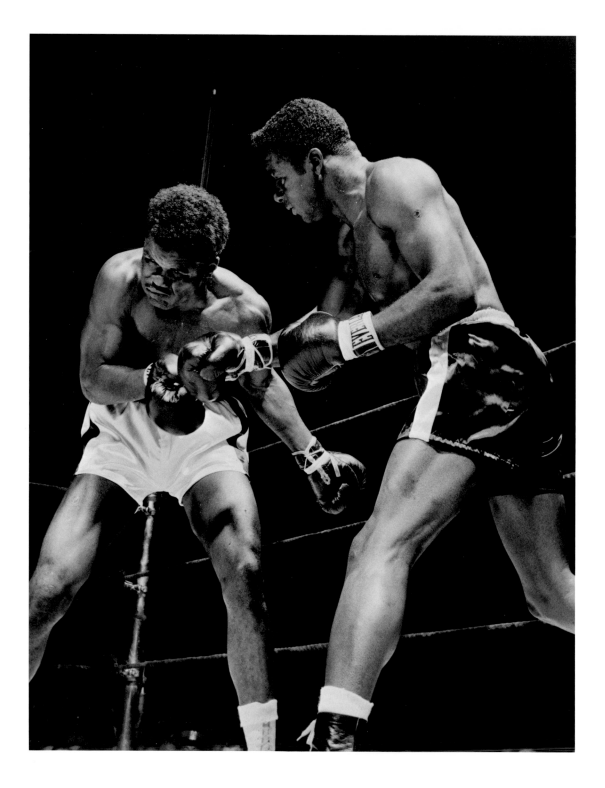

TOMMY (HURRICANE) JACKSON VS. FLOYD PATTERSON, JUNE 8, 1956

THE FIGHT:
PATTERSON VS. LISTON

JAMES BALDWIN

We, the writers—a word I am using in its most primitive sense—arrived in Chicago about ten days before the baffling, bruising, and unbelievable two minutes and six seconds at Comiskey Park. We will get to all that later. I know nothing whatever about the Sweet Science or the Cruel Profession or the Poor Boy's Game. But I know a lot about pride, the poor boy's pride, since that's my story and will, in some way, probably, be my end. There was something vastly unreal about the entire bit, as though we had all come to Chicago to make various movies and then spent all our time visiting the other fellow's set—on which no cameras were rolling. Dispatches went out every day, typewriters clattered, phones rang; each day, carloads of journalists invaded the Patterson or Liston camps, hung around until Patterson or Liston appeared; asked lame, inane questions, always the same questions, went away again, back to those telephones and typewriters; and informed a waiting, anxious world, or at least a waiting, anxious editor, what Patterson and Liston had said or done that day. It was insane and desperate, since neither of them ever really *did* anything. There wasn't anything for them *to* do except train for the fight. But there aren't many ways to describe a fighter in training—it's muscle and sweat and grace, it's the same thing over and over—and since neither Patterson nor Liston were doing much boxing, there couldn't be any interesting thumbnail sketches of their sparring partners. The "feud" between Patterson and Liston was as limp and tasteless as British roast lamb. Patterson is really far too much of a gentleman to descend to feuding with anyone, and I simply never believed, especially after talking with Liston, that he had the remotest grudge against Patterson. So there we were, hanging around, twiddling our thumbs, drinking Scotch, and telling stories, and trying to make copy out of

nothing. And waiting, of course, for the Big Event, which would justify the monumental amounts of time, money, and energy which were being expended in Chicago.

Neither Patterson nor Liston have the *color*, or the instinct for drama which is possessed to such a superlative degree by the marvelous Archie Moore, and the perhaps less marvelous, but certainly vocal and rather charming, Cassius Clay. In the matter of color, a word which I am not now using in its racial sense, the press room far outdid the training camps. There were not only the sports writers, who had come, as I say, from all over the world: there were also the boxing greats, scrubbed and sharp and easygoing, Rocky Marciano, Barney Ross, Ezzard Charles, and the King, Joe Louis, and Ingemar Johansson, who arrived just a little before the fight and did not impress me as being easygoing at all. Archie Moore's word for him is *desperate*, and he did not say this with any affection. There were the ruined boxers, stopped by an unlucky glove too early in their careers, who seemed to be treated with the tense and embarrassed affection reserved for faintly unsavory relatives, who were being used, some of them, as sparring partners. There were the managers and trainers, who, in public anyway, and with the exception of Cus D'Amato, seemed to have taken, many years ago, the vow of silence. There were people whose functions were mysterious indeed, certainly unnamed possibly unnameable, and, one felt, probably, if undefinably, criminal. There were hangers-on and protégés, a singer somewhere around, whom I didn't meet, owned by Patterson, and another singer owned by someone else—who couldn't sing, everyone agreed, but who didn't have to, being so loaded with personality—and there were some improbable-looking women, turned out, it would seem, by a machine shop, who didn't seem, really, to walk or talk, but rather to gleam, click, and glide with an almost soundless meshing of gears. There were some pretty incredible girls, too, at the parties, impeccably blank and beautiful and rather incredibly vulnerable. There were the parties and the postmortems and the gossip and speculations and recollections and the liquor and the anecdotes, and dawn coming up to find you leaving somebody else's house or somebody else's room or the Playboy Club; and Jimmy Cannon, Red Smith, Milton Gross, Sandy Grady, and A. J. Liebling; and Norman Mailer, Gerald Kersh, Budd Schulberg, and Ben Hecht—who arrived, however, only for the fight and must have been

left with a great deal of time on his hands—and Gay Talese (of the *Times*), and myself. Hanging around in Chicago, hanging on the slightest word, or action, of Floyd Patterson and Sonny Liston.

I am not an aficionado of the ring, and haven't been since Joe Louis lost his crown—he was the last great fighter for me—and so I can't really make comparisons with previous events of this kind. But neither, it soon struck me, could anybody else. Patterson was, in effect, the *moral* favorite—people *wanted* him to win, either because they liked him, though many people didn't, or because they felt that his victory would be salutary for boxing and that Liston's victory would be a disaster. But no one could be said to be enthusiastic about either man's record in the ring. The general feeling seemed to be that Patterson had never been tested, that he was the champion, in effect, by default; though, on the other hand, everyone attempted to avoid the conclusion that boxing had fallen on evil days and that Patterson had fought no worthy fighters because there were none. The desire to avoid speculating too deeply on the present state and the probable future of boxing was responsible, I think, for some very odd and stammering talk about Patterson's personality. (This led Red Smith to declare that he didn't feel that sports writers had any business trying to be psychiatrists, and that he was just going to write down who hit whom, how hard, and where, and the hell with why.) And there was very sharp disapproval of the way Patterson has handled his career, since he has taken over most of D'Amato's functions as a manager, and is clearly under no one's orders but his own. "In the old days," someone claimed, "the manager told the fighter what to do, and he did it. You didn't have to futz around with the guy's *temperament*, for Christ's sake." Never before had any of the sports writers been compelled to deal directly with the fighter instead of with his manager, and all of them seemed baffled by this necessity and many were resentful. I don't know how they got along with D'Amato when he was running the entire show—D'Amato can certainly not be described as either simple or direct—but at least the figure of D'Amato was familiar and operated to protect them from the oddly compelling and touching figure of Floyd Patterson, who is quite probably the least likely fighter in the history of the sport. And I think that part of the resentment he arouses is due to the fact that he brings to what is thought of—quite erroneously—as a simple activity a terrible note of complexity. This is his

personal style, a style which strongly suggests that most un-American of attributes, privacy, the will to privacy; and my own guess is that he is still relentlessly, painfully shy—he lives gallantly with his scars, but not all of them have healed—and while he has found a way to master this, he has found no way to hide it, as, for example, another miraculously tough and tender man, Miles Davis, has managed to do. Miles's disguise would certainly never fool anybody with sense, but it keeps a lot of people away, and that's the point. But Patterson, tough and proud and beautiful, is also terribly vulnerable, and looks it.

I met him, luckily for me, with Gay Talese, whom he admires and trusts, I say luckily because I'm not a very aggressive journalist, don't know enough about boxing to know which questions to ask, and am simply not able to ask a man questions about his private life. If Gay had not been there, I am not certain how I would ever have worked up my courage to say anything to Floyd Patterson—especially after having sat through, or suffered, the first, for me, of many press conferences. I only sat through two with Patterson, silently, and in the back—he, poor man, had to go through it every day, sometimes twice a day. And if I don't know enough about boxing to know which questions to ask, I must say that the boxing experts are not one whit more imaginative, though they were, I thought, sometimes rather more insolent. It was a curious insolence, though, veiled, tentative, uncertain—they couldn't be sure that Floyd wouldn't give them as good as he got. And this led, again, to that curious resentment I mentioned earlier, for they were forced, perpetually, to speculate about the man instead of the boxer. It doesn't appear to have occurred yet to many members of the press that one of the reasons their relations with Floyd are so frequently strained is that he has no reason, on any level, to trust them, and no reason to believe that they would be capable of hearing what he had to say, even if he could say it. Life's far from being as simple as most sports writers would like to have it. The world of sports, in fact, is far from being as simple as the sports pages often make it sound.

Gay and I drove out, ahead of all the other journalists, in a Hertz car, and got to the camp at Elgin while Floyd was still lying down. The camp was very quiet, bucolic, really, when we arrived; set in the middle of small, rolling hills; four or five buildings, a tethered goat—the camp

mascot; a small, green tent containing a Spartan cot; lots of cars. "They're very car-conscious here," someone said of Floyd's small staff of trainers and helpers. "Most of them have two cars." We ran into some of them standing around and talking on the grounds, and Buster Watson, a close friend of Floyd's, stocky, dark, and able, led us into the press room. Floyd's camp was actually Marycrest Farm, the twin of a Chicago settlement house, which works, on a smaller scale but in somewhat the same way, with disturbed and deprived children, as does Floyd's New York alma mater, the Wiltwych School for Boys. It is a Catholic institution—Patterson is a converted Catholic—and the interior walls of the building in which the press conference took place were decorated with vivid mosaics, executed by the children in colored beans, of various biblical events. There was an extraordinarily effective crooked cross, executed in charred wood, hanging high on one of the walls. There were two doors to the building in which the two press agents worked, one saying *Caritas*, the other saying *Veritas*. It seemed an incongruous setting for the life being lived there, and the event being prepared, but Ted Carroll, the Negro press agent, a tall man with white hair and a knowledgeable, weary, gentle face, told me that the camp was like the man. "The man lives a secluded life. He's like this place—peaceful and far away." It was not all that peaceful, of course, except naturally; it was otherwise menaced and inundated by hordes of human beings, from small boys who wanted to be boxers to old men who remembered Jack Dempsey as a kid. The signs on the road, pointing the way to Floyd Patterson's training camp, were perpetually carried away by souvenir hunters. ("At first," Ted Carroll said, "we were worried that maybe they were carrying them away for another reason—you know, the usual hassle—but no, they just want to put them in the rumpus room.") We walked about with Ted Carroll for a while, and he pointed out to us the house, white, with green shutters, somewhat removed from the camp and on a hill, in which Floyd Patterson lived. He was resting now, and the press conference had been called for three o'clock, which was nearly three hours away. But he would be working out before the conference. Gay and I left Ted and wandered close to the house. I looked at the ring, which had been set up on another hill near the house, and examined the tent. Gay knocked lightly on Floyd's door. There was no answer, but Gay said that the radio was on. We sat down in

the sun, near the ring, and speculated on Floyd's training habits, which kept him away from his family for such long periods of time.

Presently, here he came across the grass, loping, rather, head down, with a small, tight smile on his lips. This smile seems always to be there when he is facing people and disappears only when he begins to be comfortable. Then he can laugh, as I never heard him laugh at a press conference, and the face which he watches so carefully in public is then, as it were, permitted to be its boyish and rather surprisingly zestful self. He greeted Gay and took sharp, covert notice of me, seeming to decide that if I were with Gay, I was probably all right. We followed him into the gym, in which a large sign faced us, saying *So we being many are one body in Christ.* He went through his work-out, methodically, rigorously, pausing every now and again to disagree with his trainer, Dan Florio, about the time—he insisted that Dan's stopwatch was unreliable—or to tell Buster that there weren't enough towels, or to ask that the windows be closed. "You threw a good right hand that time," Dan Florio said; and, later, "Keep the right hand *up. Up!*" "We got a floor scale that's no good," Floyd said, cheerfully. "Sometimes I weigh two hundred, sometimes I weigh eighty-eight." And we watched him jump rope, which he must do according to some music in his head, very beautiful and gleaming and far away, like a boy saint helplessly dancing and seen through the steaming windows of a storefront church.

We followed him into the house when the workout was over, and sat in the kitchen and drank tea; he drank chocolate. Gay knew that I was somewhat tense as to how to make contact with Patterson—my own feeling was that he had a tough enough row to hoe, and that everybody should just leave him alone; how would *I* like it if I were forced to answer inane questions every day concerning the progress of my work?—and told Patterson about some of the things I'd written. But Patterson hadn't heard of me, or read anything of mine. Gay's explanation, though, caused him to look directly at me, and he said, "I've seen you someplace before. I don't know where, but I know I've seen you." I hadn't seen him before, except once, with Liston, in the commissioner's office when there had been a spirited fight concerning the construction of Liston's boxing gloves, which were "just like wearing no gloves at all." I felt certain, considering the number

of people and the tension in that room, that he could not have seen me *then*—but we do know some of the same people, and have walked very often on the same streets. Gay suggested that he had seen me on TV. I had hoped that the contact would have turned out to be more personal, like a mutual friend or some activity connected with the Wiltwyck School, but Floyd now remembered the subject of the TV debate he had seen—the race problem, of course—and his face lit up. "I *knew* I'd seen you somewhere!" he said, triumphantly, and looked at me for a moment with the same brotherly pride I felt—and feel—in him.

By now he was, with good grace but a certain tense resignation, preparing himself for the press conference. I gather that there are many people who enjoy meeting the press—and most of them, in fact, were presently in Chicago—but Floyd Patterson is not one of them. I think he hates being put on exhibition, he doesn't believe it is real; while he is terribly conscious of the responsibility imposed on him by the title which he held, he is also afflicted with enough imagination to be baffled by his position. And he is far from having acquired the stony and ruthless perception which will allow him to stand at once within and without his fearful notoriety. Anyway, we trailed over to the building in which the press waited, and Floyd's small, tight, shy smile was back.

But he has learned, though it must have cost him a great deal, how to handle himself. He was asked about his weight, his food, his measurements, his morale. He had been in training for nearly six months ("Is it necessary?" "I just like to do it that way"), had boxed, at this point, about 162 rounds. This was compared to his condition at the time of the first fight with Ingemar Johansson. "Do you believe that you were overtrained for that fight?" "Anything I say now would sound like an excuse." But, later, "I was careless—not overconfident, but careless." He had allowed himself to be surprised by Ingemar's aggressiveness. "Did you and D'Amato fight over your decision to fight Liston?" The weary smile played at the corner of Floyd's mouth, and though he was looking directly at his interlocutors, his eyes were veiled. "No." Long pause. "Cus knows that I do what I want to do—ultimately, he accepted it." Was he surprised by Liston's hostility? No. Perhaps it had made him a bit more determined. Had he anything against Liston personally? "No. I'm the champion and I want to remain the champion." Had he and D'Amato ever disagreed before? "Not

in relation to my opponents." Had he heard it said that, as a fighter, he lacked viciousness? "Whoever said that should see the fights I've won without being vicious." And why was he fighting Liston? "Well," said Patterson, "it was my decision to take the fight. You gentlemen disagreed, but you were the ones who placed him in the number one position, so I felt that it was only right. Liston's criminal record is behind him, not before him." Do you feel that you've been accepted as a champion? Floyd smiled more tightly than ever and turned toward the questioner. "No," he said. Then, "Well, I have to be accepted as the champion—but maybe not a good one." "Why do you say," someone else asked, "that the opportunity to become a great champion will never arise?" "Because," said Floyd, patiently, "you gentlemen will never let it arise." Someone asked him about his experiences when boxing in Europe—what kind of reception had he enjoyed? Much greater and much warmer than here, he finally admitted, but added, with a weary and humorous caution, "I don't want to say anything derogatory about the United States. I am satisfied." The press seemed rather to flinch from the purport of this grim and vivid little joke, and switched to the subject of Liston again. Who was most in awe of whom? Floyd had no idea, he said, but, "Liston's confidence is on the surface. Mine is within."

And so it seemed to be indeed, as, later, Gay and I walked with him through the flat, midwestern landscape. It was not exactly that he was less tense—I think that he is probably always tense, and it is that, and not his glass chin, or a lack of stamina, which is his real liability as a fighter—but he was tense in a more private, more bearable way. The fight was very much on his mind, of course, and we talked of the strange battle about the boxing gloves, and the commissioner's impenetrable and apparent bias toward Liston, though the difference in the construction of the gloves, and the possible meaning of this difference, was clear to everyone. The gloves had been made by two different firms, which was not the usual procedure, and though they were the same standard eight-ounce weight, Floyd's gloves were the familiar, puffy shape, with most of the weight of the padding over the fist, and Liston's were extraordinarily slender, with most of the weight of the padding over the wrist. But we didn't talk only of the fight, and I can't now remember all the things we *did* talk about. I mainly remember Floyd's voice going cheerfully on and on,

and the way his face kept changing, and the way he laughed; I remember the glimpse I got of him then, a man more complex than he was yet equipped to know, a hero for many children who were still trapped where he had been, who might not have survived without the ring, and who yet, oddly, did not really seem to belong there. I dismissed my dim speculations, that afternoon, as sentimental inaccuracies rooted in my lack of knowledge of the boxing world, and corrupted with a guilty chauvinism. But now I wonder. He told us that his wife was coming in for the fight, against his will, "in order," he said indescribably, "to *console* me if—" and he made, at last, a gesture with his hand, downward.

Liston's camp was very different, an abandoned racetrack in, or called, Aurora Downs, with wire gates and a uniformed cop, who lets you in, or doesn't. I had simply given up the press conference bit, since they didn't teach me much, and I couldn't ask those questions. Gay Talese couldn't help me with Liston, and this left me floundering on my own until Sandy Grady called up Liston's manager, Jack Nilon, and arranged for me to see Liston for a few minutes alone the next day. Liston's camp was far more outspoken concerning Liston's attitude toward the press than Patterson's. Liston didn't like most of the press, and most of them didn't like him. But I didn't, myself, see any reason why he *should* like them, or pretend to—they had certainly never been very nice to him, and I was sure that he saw in them merely some more ignorant, uncaring white people, who, no matter how fine we cut it, had helped to cause him so much grief. And this impression was confirmed by reports from people who *did* get along with him—Wendell Phillips and Bob Teague, who are both Negroes, but rather rare and salty types, and Sandy Grady, who is not a Negro, but is certainly rare, and very probably salty. I got the impression from them that Liston was perfectly willing to take people as they were, if they would do the same for him. Again, I was not particularly appalled by his criminal background, believing, rightly or wrongly, that I probably knew more about the motives and even the necessity of this career than most of the white press could. The only relevance Liston's—presumably previous—associations should have been allowed to have, it seemed to me, concerned the possible effect of these on the future of boxing. Well, while the air was thick with rumor and gospel on this subject, I really cannot go into it

without risking, at the very least, being sued for libel; and so, one of the most fascinating aspects of the Chicago story will have to be left in the dark. But the Sweet Science is not, in any case, really so low on shady types as to be forced to depend on Liston. The question is to what extent Liston is prepared to cooperate with whatever powers of darkness there are in boxing; and the extent of his cooperation, we must suppose, must depend, at least partly, on the extent of his awareness. So that there is nothing unique about the position in which he now finds himself and nothing unique about the speculation which now surrounds him.

I got to his camp at about two o'clock one afternoon. Time was running out, the fight was not more than three days away, and the atmosphere in the camp was, at once, listless and electric. Nilon looked as though he had not slept and would not sleep for days, and everyone else rather gave the impression that they wished they could—except for three handsome Negro ladies, related, I supposed, to Mrs. Liston, who sat, rather self-consciously, on the porch of the largest building on the grounds. They may have felt, as I did, that training camps are like a theater before the curtain goes up, and if you don't have a function in it, you're probably in the way.

Liston, as we all know, is an enormous man, but surprisingly trim. I had already seen him work out, skipping rope to a record of "Night Train," and, while he wasn't nearly, for me, as moving as Patterson skipping rope in silence, it was still a wonderful sight to see. The press has really maligned Liston very cruelly, I think. He is far from stupid; is not, in fact, stupid at all. And, while there is a great deal of violence in him, I sensed no cruelty at all. On the contrary, he reminded me of big, Black men I have known who acquired the reputation of being tough in order to conceal the fact that they weren't hard. Anyone who cared to could turn them into taffy. Anyway, I liked him, liked him very much. He sat opposite me at the table, sideways, head down, waiting for the blow: for Liston knows, as only the inarticulately suffering can, just how inarticulate he is. But let me clarify that: I say suffering because it seems to me that he has suffered a great deal. It is in his face, in the silence of that face, and in the curiously distant light in the eyes—a light which rarely signals because there have been so few answering signals. And when I say inarticulate, I really do not mean to suggest that he does not know how to talk. He is inarticulate in the way we all are

when more has happened to us than we know how to express; and inarticulate in a particularly Negro way—he has a long tale to tell which no one wants to hear. I said, "I can't ask you any questions because everything's been asked. Perhaps I'm only here, really, to say that I wish you well." And this was true, even though I wanted Patterson to win. Anyway, I'm glad I said it because he looked at me then, really for the first time, and he talked to me for a little while.

And what had hurt him most, somewhat to my surprise, was not the general press reaction to him, but the Negro reaction. "Colored people," he said, with great sorrow, "say they don't want their children to look up to me. Well, they ain't teaching their children to look up to Martin Luther King, either." There was a pause. "I wouldn't be no bad example if I was up there. I could tell a lot of those children what they need to know—because—I passed that way. I could make them *listen*." And he spoke a little of what he would like to do for young Negro boys and girls, trapped in those circumstances which so nearly defeated him and Floyd, and from which neither can yet be said to have recovered. "I tell you one thing, though," he said. "If I was up there, I wouldn't bite my tongue." I could certainly believe that. And we discussed the segregation issue, and the role in it of those prominent Negroes who find him so distasteful. "I would never," he said, "go against my brother—we got to learn to stop fighting among our own." He lapsed into silence again. "They said they didn't want me to have the title. They didn't say that about Johansson." "They" were the Negroes. "*They* ought to know why I got some of the bum raps I got." But he was not suggesting that they were *all* bum raps. His wife came over, a very pretty woman, seemed to gather in a glance how things were going, and sat down. We talked for a little while of matters entirely unrelated to the fight, and then it was time for his workout, and I left. I felt terribly ambivalent, as many Negroes do these days, since we are all trying to decide, in one way or another, which attitude, in our terrible American dilemma, is the most effective: the disciplined sweetness of Floyd or the outspoken intransigence of Liston. And Liston is a man aching for respect and responsibility. Sometimes we grow into our responsibilities and sometimes, of course, we fail them.

I left for the fight full of weird and violent depression, which I traced partly to fatigue—it had been a pretty grueling time—partly due to the fact that I had bet more money than I should have—on Patterson—and partly to the fact that *I* had had a pretty definitive fight with someone with whom I had hoped to be friends. And I was depressed about Liston's bulk and force and his 25-pound weight advantage. I was afraid that Patterson might lose, and I really didn't want to see that. And it wasn't that I didn't like Liston. I just felt closer to Floyd.

I was sitting between Norman Mailer and Ben Hecht. Hecht felt about the same way that I did, and we agreed that if Patterson didn't get "stopped," as Hecht put it, "by a baseball bat," in the very beginning—if he could carry Liston for five or six rounds—he might very well hold the title. We didn't pay an awful lot of attention to the preliminaries—or I didn't; Hecht did; I watched the ballpark fill with people and listened to the vendors and the jokes and the speculations, and watched the clock.

From my notes: Liston entered the ring to an almost complete silence. Someone called his name, he looked over, smiled, and winked. Floyd entered, and got a hand. But he looked terribly small next to Liston, and my depression deepened.

My notes again: Archie Moore entered the ring, wearing an opera cape. Cassius Clay in black tie, and as insolent as ever. Mickey Allen sang "The Star-Spangled Banner." When Liston was introduced, some people boo'd—they cheered for Floyd, and I think I know how this made Liston feel. It promised, really, to be one of the worst fights in history.

Well, I was wrong, it was scarcely a fight at all, and I can't but wonder who on earth will come to see the rematch, if there is one. Floyd seemed all right to me at first. He had planned for a long fight, and seemed to be feeling out his man. But Liston got him with a few bad body blows, and a few bad blows to the head. And no one agrees with me on this, but, at one moment, when Floyd lunged for Liston's belly—looking, it must be said, like an amateur, wildly flailing—it seemed to me that some unbearable tension in him broke, that he lost his head. And, in fact, I nearly screamed, "Keep your head, baby!" but it was really too late. Liston got him with a left, and Floyd went down. I could not believe it. I couldn't hear the count and though Hecht said, "It's

over," and picked up his coat and left, I remained standing, staring at the ring, and only conceded that the fight was really over when two other boxers entered the ring. Then I wandered out of the ballpark, almost in tears. I met an old colored man at one of the exits who said to me, cheerfully, "I've been robbed," and we talked about it for a while. We started walking through the crowds and A. J. Liebling, behind us, tapped me on the shoulder, and we went off to a bar, to mourn the very possible death of boxing, and to have a drink, with love, for Floyd.

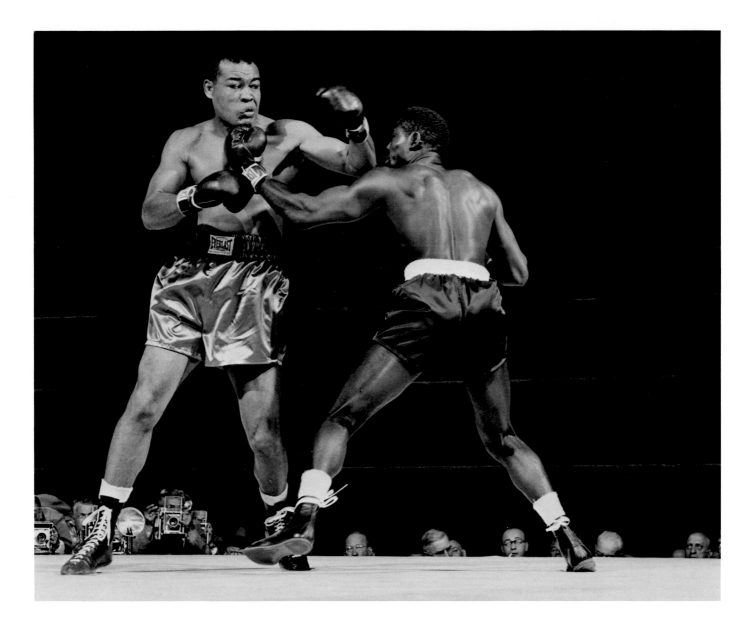

JOE LOUIS VS. EZZARD CHARLES, SEPTEMBER 27, 1950

GREAT MEN DIE TWICE

MARK KRAM

There is the feel of a cold offshore mist to the hospital room, a life-is-a-bitch feel, made sharp by the hostile ganglia of medical technology, plasma bags dripping, vile tubing snaking in and out of the body, blinking monitors leveling illusion, muffling existence down to a sort of digital bingo. The Champ, Muhammad Ali, lies there now, propped up slightly, a skim of sweat on his lips and forehead, eyes closed, an almost imperceptible tremor to his arms and head. For all his claims to the contrary, his surface romance with immortality, Ali had a spooky bead on his future; he never saw it sweeping grandly toward him but bellying quietly along the jungle floor. "We just flies in a room," he liked to say, moving quickly across the ruins of daily life, plane crashes, train wrecks, matricide, infanticide; then after swatting half of humanity, he'd lower his voice and whisper, as if imparting a secret, "We just flies, that's all. Got nowhere to fly, do we?"

Images and echoes fill the room, diffuse and speeding, shot through with ineluctable light and the mythopoeic for so long, the glass darkened to a degree no one thought possible. His immense talent, his ring wisdom, his antipathy for chemicals, argued against destructibility: all he would ever do is grow old. For twenty years, while he turned the porno shop of sports into international theater, attention was paid in a way it never was before or has been since. The crowds were a wonder to behold. Kids scaled the wings of jets to get a glimpse of him; thousands, young and old, tailed him in masses during his roadwork. World leaders marveled at the spell he cast over the crowds. "If you were a Filipino," joked Ferdinand Marcos, "I'd have to shoot you." The pope asked for his autograph. "Sure," he said, pointing to a picture, "but why ain't Jesus black?" A young Libyan student in London sat on his bed, kept him up half the night with dithyrambic visions of Muslim revolution. "Watch, one day you will see," said Muammar Qaddafi. Half asleep, Ali said, "Sheeeet, you crazy." Leonid Brezhnev once dispatched a note to an official at Izvestia: "I would like to see more on Muhammad Ali. Who is this man?"

The Ali Watch: how absurd that it would one day drop down here on a little hospital on Hilton Head Island, South Carolina. The nurse dabs his face dry. What is he thinking? Never has his favorite phrase sounded so dismally precise: My, my, ain't the world strange. If he could root back through the maze of moment and incident, would he find premonitory signs sticking out like dire figurations of chicken entrails? Does he remember King Levinsky, one of the many heavy bags for Joe Louis, in the corridor after the Miami Beach weigh-in? Boldly colored ties draped Levinsky's neck (he sold them on the street), his synapses now like two eggs over light, in permanent sizzle, as he tried to move into stride with a young Cassius Clay. Over and over, like a one-man Greek chorus, Levinsky croaked, eyes spinning, spittle bubbling from his lips: He's gonna take you, kid. Liston's gonna take you, make you a guy sellin' ties. . . . Partners with me kid, ya kin be partners with me. Does he remember a shadowed evening in his hotel room a day or so after the third Joe Frazier fight, moving to the window, his body still on fire from the assault? He stood there watching the bloodred sun drop into Manila Bay, then took a visitor's hand and guided it over his forehead, each bump sending a vague dread through the fingers. "Why I do this?" he said softly. Does he remember the Bahamian cowbell tinkling the end of his final, pathetic fight, a derisive good-bye sound stark with omen? What is he thinking?

Ali poses a question, his eyes closed, his lips parting as if he were sliding open manhole covers. "You die here . . . they take you home?" he asks. The nurses roll their eyes and smile, struck by his innocence; it has nothing to do, they know, with morbidity. He is not joking either. The practical aftermath of death seems to stimulate his curiosity these days; nothing urgent, mind you, just something that begins to get in your mind when you're watching blood move in and out of your body for half the day. Though he is very much a mystic, there is a part of Ali that has always found security and a skewed understanding of life in the quantifiable: amounts, calibrated outcomes, the creaking, reassuring machinery of living. The night before, in the hotel lounge, with his wife, Lonnie, beside him, bemusedly aghast, he grilled a pleasant waitress until he knew how many tips she got each week, how many children she had, the frequency of men hitting on her, and the general contour of her reality. "She have a sad life," he said later. The nurse now cracks with a deadpan expression: "You die, we take you home, Muhammad."

Still, a certain chiaroscuro grimness attaches to their surreal exchange and cries out for some brainless, comic intervention. He himself had long been a specialist in such relief when he would instantly brighten faces during his favorite tours of prisons, orphanages, and nursing homes. When down himself (very seldom), he could count on a pratfall from his hysterical shaman, Drew "Bundini" Brown, on the latest bizarre news from his scheming court, maybe a straight line from some reporter that he would turn into a ricocheting soliloquy on, say, the disgusting aesthetics of dining on pig. No laughs today, though.

"Don't make him laugh," a nurse insisted when leading a writer and a photographer into the room. "Laughing shakes the tubing loose." The photographer is Howard Bingham, Ali's closest friend; he's been with the Champ from the start, in the face of much abuse from the Black Muslims. Ali calls him "the enemy" or "the nonbeliever." His natural instinct is to make Ali laugh; today he has to settle for biting his lower lip and gazing warily back and forth between Ali and his nurses. He doesn't know what to do with his hands. Ali had requested that he leave his cameras outside; just one shot of this scene, of Ali on his back, the forbidding purge in progress, of fame and mystique splayed raw, would bring Bingham a minor fortune. "He doesn't want the world to see him like this," says Howard. "I wouldn't take the picture for a million dollars."

The process is called plasmapheresis. It lasts five hours and is being conducted by Dr. Rajko Medenica. The procedure, popular in Europe, is a cleansing of the blood. Ali is hooked up to an electrocardiograph and a blood-pressure monitor; there is always some risk when blood is not making its customary passage. But the procedure is not dangerous and he is in no pain, we are told. Two things, though, that he surely can't abide about the treatment: the injection of those big needles and the ceaseless tedium. When he was a young fighter, a doctor had to chase him around a desk to give him a shot, and chaotic mobility to him is at least as important as breathing. Bingham can't take his eyes off Ali; the still life of his friend, tethered so completely, seems as incomprehensible to him as it would to others who followed the radiated glow of Ali's invulnerability. The nurses cast an eye at his blood pressure and look at each other. His pressure once jumped twelve points while he watched a TV report on Mike Tyson's street fight with Mitch

Green in Harlem. It's rising a bit now, and the nurses think he has to urinate. He can't bear relieving himself in the presence of women; he resists, and his anxiety climbs.

"Ali," one of them calls. His eyes remain closed, his breathing is hardly audible. The nurse calls to him again; no response. "Come on now, Ali," she complains, knowing that he likes to feign death. "Now, stop it, Ali." He doesn't move, then suddenly his head gives a small jerk forward and his eyes buck wide open, the way they used to when he'd make some incoherent claim to lineage to the gods. The nurses flinch, or are they in on the joke, too? Eyes still wide, with a growing smile, he says to the writer, weakly: "You thought I dead, tell the truth. You the only one ever here to see this and I die for ya. You git some scoop, big news round the whole world, won't it be?" He leans his head back on the pillow, saying, "Got no funny people round me anymore. Have to make myself laugh." The nurse wants to know if he has to urinate. "No," he says with a trace of irritation. "Yes, you do," the nurse says. "Your pressure . . ." Ali looks over at Lonnie with mischievous eyes. "I just thinkin' 'bout a pretty woman." The nurse asks him what he'd like for lunch. "Give him some pork," cracks Bingham. Ali censures the heretic with a playful stare. Ali requests chicken and some cherry pie with "two scoops of ice cream." He turns to the writer again: "Abraham Lincoln went on a three-day drunk, and you know what he say when he wake up?" He waits for a beat, then says: "I freed whooooooo?" His body starts to shake with laughter. The nurse yells, "Stop it, Muhammad! You'll drive the needles through your veins." He calms down, rasps, "I'll never grow up, will I? I'll be fifty in three years. Old age just make you ugly, that's all."

Not all, exactly; getting old is the last display for the bread-and-circuses culture. Legends must suffer for all the gifts and luck and privilege given to them. Great men, it's been noted, die twice— once as great and once as men. With grace, preferably, which adds an uplifting, stirring, Homeric touch. If the fall is too messy, the national psyche will rush toward it, then recoil; there is no suspense, no example, in the mundane. The captivating aspiring sociopath Sonny Liston had a primitive hold on the equation of greatness. "Clay [he never called him Ali] beeeg now," Sonny once said while gnawing on some ribs. "He flyin' high now. Like an eagle. So high. Where he gonna

land, how he gonna land? He gonna have any wings? I wanna see." Sonny, of course, never made it for the final show. Soon after, he checked out in Vegas, the suspicion of murder hovering over the coroner's report.

Who wanted to ask the question back then, or even be allowed to examine in depth its many possibilities? It was too serious for the carnival, immediately at odds with the cartoon bombast that swirled around Ali, the unassailable appeal of the phenomenon, the breathtaking climb of the arc. Before him, the ring, if not moribund, had been a dark, somber corner of sports, best described by the passing sight of then-middleweight-king Dick Tiger, leaving his beat-up hotel wearing a roomy black homburg and a long pawnshop overcoat, a black satchel in his hand, heading for the subway and a title fight at the Garden. But the heavyweight champions—as they always will—illuminated the image sent out to the public. There was the stoic, mute Joe Louis, with his cruising menace; the street fighter Rocky Marciano, with his trade-unionist obedience; the arresting and dogged Floyd Patterson, who would bare his soul to a telephone pole at the sight of a pencil—all unfrivolous men who left no doubt as to the nature of their work.

With the emergence of Muhammad Ali, no one would ever see the ring the same way again, not even the fighters themselves. A TV go, a purse, and a sheared lip would never be enough, and a title was just a belt unless you did something with it. A fighter had to be—a product, an event, transcendental. Ali and the new age met stern, early resistance. He was the demon loose at a holy rite. With his preening narcissism, braggart mouth, and stylistic quirks, he was viewed as a vandal of ring tenets and etiquette. Besides, they said, he couldn't punch, did not like to get hit, and seemed to lack a sufficient amount of killer adrenalin. True, on the latter two counts. "I git no pleasure from hurtin' another human bein'," he used to say. "I do what I gotta do, nothin' more, nothin' less." As far as eating punches, he said, "Only a fool wanna be hit. Boxin' just today, my face is forever." Others saw much more. The ballet master Balanchine, for one, showed up at a workout and gazed in wonder. "My God," he said, "he fights with his legs, he actually fights with his legs. What an astonishing creature." Ali's jab (more like a straight left of jolting electricity) came in triplets, each a thousandth of a second in execution. He'd double up cruelly with a left

hook (rarely seen) and razor in a right—and then he'd be gone. Even so, it took many years for Ali to ascend to a preeminent light in the national consciousness. In the sixties, as a converted Black Muslim, he vilified white people as blond, blue-eyed devils. His position on Vietnam—"I ain't got no quarrel with those Vietcong, anyway. They never called me nigger"—was innocent at first, but then taken up as if he were the provocateur of a national crisis. The politicians, promoters, and sweeping sentiment converged to conspire against his constitutional right to work: states barred him from fighting. He resisted the draft and drifted into exile. Three years later he returned, heavier, slower, but with a new kind of fire in his belly. Though he had defeated heavyweight champion Sonny Liston and defended his title nine times, Ali had never had a dramatic constituency before. Now a huge one awaited him, liberals looking for expression, eager literati to put it in scripture, worn-out hippies, anyone who wanted to see right done for once. The rest is history: his two symphonic conflicts with Joe Frazier; the tingling walk with him into the darkness of George Foreman. Then, the Hegelian "bad infinite" of repeating, diminishing cycles: retiring, unretiring, the torture of losing weight, the oiling of mushy reflexes. The margins of dominance compressed perilously, and the head shots (negligible before exile) mounted.

Greatness trickled from the corpus of his image, his career now like a gutshot that was going to take its time before killing. His signing to fight Larry Holmes, after retiring a second time, provoked worried comment. After watching some of Ali's films, a London neurologist said that he was convinced Ali had brain damage. Diagnosis by long distance, the promoters scoffed. Yet among those in his camp, the few who cared, there was an edginess. They approached Holmes, saying, "Don't hurt him, Larry." Moved, Holmes replied, "No way. I love Ali." With compassion, he then took Ali apart with the studied carefulness of a diamond cutter; still, not enough to mask the winces ringside. Ali failed to go the route for the first time in his career. Incredibly, fourteen months later, in 1981, his ego goaded him to the Bahamas and another fight, the fat jellied on his middle, his hand speed sighing and wheezing like a busted old fan; tropic rot on the trade winds. Trevor Berbick, an earnest plug, outpointed him easily. Afterward, Angelo Dundee, who had trained Ali from the start and had to be talked into showing up for this one, watched

him slumped in the dressing room, then turned away and rubbed his eyes as certain people tried to convince Ali that he had been robbed and that a fourth title was still possible.

The public prefers, indeed seems to insist on, the precedent set by Rocky Marciano, who quit undefeated, kept self-delusion at bay. Ali knew the importance of a clean farewell, not only as a health measure but as good commercial sense. His ring classicism had always argued so persuasively against excessive physical harm; his pride was beyond anything but a regal exit. But his prolonged decline had been nasty, unseemly. Who or what pressured him to continue on? Some blamed his manager, Herbert Muhammad, who had made millions with Ali. Herbert said that his influence wasn't that strong.

Two years after that last fight, Ali seemed as mystified as everyone else as to why he hadn't ended his career earlier. He was living with his third wife, the ice goddess Veronica, in an L. A. mansion, surrounded by the gifts of a lifetime—a six-foot hand-carved tiger given to him by Teng Hsiao-p'ing, a robe given to him by Elvis Presley. Fatigued, his hands trembling badly, he sat in front of the fire and could only say, "Everybody git lost in life. I just git lost, that's all."

Now, five years later, the question why still lingers, along with the warning of the old aphorism that "we live beyond what we enact." The resuscitation of Ali's image has been a sporadic exercise for a long time now, some of it coming from friends who have experienced heartfelt pain over his illness. Others seem to be trying to assuage a guilt known only to themselves, and a few are out to keep Ali a player, a lure to those who might want to use his name in business, though the marketplace turns away from billboards in decline. Not long ago, a piece in *The New York Times Magazine* pronounced him the Ali of old, just about terminally perky. Then, Ali surfaced in a front-page telephone interview in the *Washington Post*. He appeared to have a hard grasp on politics, current states'-rights issues, and federal judgeships being contested—a scenario that had seemed as likely as the fusillade of laser fire Ali said Muslim spaceships would one day loose on the white devils.

Noses began to twitch. What and who was behind the new Ali, the wily Washington lobbyist

who had the ear of everyone from Strom Thurmond to Orrin Hatch? The wife of Senator Arlen Specter even baked Ali a double-chocolate-mousse pie. For a good while, most of these senators, and others, knew only the voice of Ali on the phone. Dave Kindred, a columnist for the *Atlanta Journal-Constitution* who has known Ali since his Louisville days, concluded that it was most likely Ali's attorney, Richard Hirschfeld, widely regarded as a brilliant impersonator of Ali, who had made the calls. (Hirschfeld has refused to comment on whether or not he did so.) Hirschfeld and Ali had cut up a lot of money over the years on numerous enterprises (funded by other people), from hotels to cars, most of them failing. Ali's lobbying seemed to center on a federal judgeship for a Hirschfeld friend, and a federal lawsuit in which Ali sought $50 million in damages from his "wrongful conviction in the 1967 draft evasion case." He lost the suit but succeeded in getting Senator Hatch and others to explore a loophole that might remedy the verdict. Ali eventually had to materialize (with Hirschfeld hard by his side), and many on Capitol Hill were unable to match the man with the voice. One of Sam Nunn's aides, noting Ali's listlessness and Hirschfeld's aggressive quizzing, wondered: "Is Ali being carted around like a puppet?" Certainly a serpentine tale; but had Ali been a collaborator all along?

At his farm in Berrien Springs, Michigan, Ali sits at the end of a table in the living room. The 247 pounds of weight have made him a bit short of breath. He's battled his appetite (two, three desserts, meals back to back) and sedentary lapses for years. Several months before, he had been almost sleek, thanks to fourteen-mile walks and his wife's efforts to police him at the table. But what is disturbing is the general profile of his condition.

For a long time now, he has appeared indifferent to the ravages of his problem. But he dispels that notion when asked how seriously he considered a dangerous brain operation in Mexico before his family talked him out of it. "Scale of ten," he says, "a six." The answer reflects the terrible frustration that must exist within him, the daily, fierce struggle with a body and mind that will not capitulate to his bidding. He sits there, his hands shaking, his movements robotic, the look on his face similar to what the Marines call a thousand-yard stare.

Why is it, do you think, that after all these years, the dominant sound around Ali is silence? Look at the cataract of noise caught by TV sound men, look at the verbosity that snared some novelists into thinking he was a primitive intelligence capable of Ciceronian insight. Part of the fever of the times; if the Black Panther Huey Newton, posing with rifle and spear, could be written up as a theoretical genius and his partner, Bobby Seale, interpreted as a tactical wizard, then how much a symbol was Ali, the first to tap and manifest glinting black pride, to dispute with vigor erosive self-laceration.

The fact was that he was not cerebral; he was a reflex of confusing emotions and instant passions. He did have street cunning, most of it aimed at keeping himself a mystery. "People like mystery," he used to say. "Who is he? What's he all about? Who's he gonna be tomorrow?" To that end, he tossed the media rabble dripping hunks of redundant, rote monologue; his loudness provided a great show and diverted probing questions. By nature, he was a gentle, sensitive man, and even in the throes of angry threats against whites it was hard to hide a smile, for he loved what the blacks call "selling wolf tickets," tricking people into fear. The Black Panthers used that gambit well, and the TV crews followed their comings and goings. Thinking of all this, how could someone so alien to ideas and thought, who communicated privately, in scraps and remote silences, be capable of fooling Washington politicians? Absurd, of course, but then the question emerges: did he allow himself to be used?

"How about all those phone calls?" he is asked.

"What calls?" he responds, vacantly.

"To politicians this past summer."

"You can't believe that," he says. "Man wrote that, he's a cracker from way back in Louisville. Always hated blacks."

"But the piece had the goods."

"I'm signin' my autographs now," he says. "This the only important thing in my life. Keepin' in touch with the people."

"Were you used?"

"For what?"

"To influence your lawsuit."

"I ain't worried about money," he says.

"Maybe you just want to be big again. Remember what you told Elvis. 'Elvis, you have to keep singin' or die to stay big. I'm gonna be big forever.'"

He smiles thinly: "I say anything shock the world."

"You like politics now?"

"Politics put me to sleep."

"You were at the Republican National Convention."

"You borin' me, putting me to sleep."

"Reagan, Hatch, Quayle, they would've clapped you in jail in the old days."

His eyes widen slightly: "That right?" He adds, "I'm tired. You better than a sleepin' pill."

But don't let the exchange mislead. Ali is not up to repartee these days, never was, really, unless he was in the mood, and then he'd fade you with one of his standard lines ("You not as dumb as you look"). He speaks very, very slowly, and you have to lean in to hear him. It takes nearly an hour to negotiate the course of a conversation. Typically, he hadn't been enlightening on the Capitol Hill scam. Over the years, he has been easily led, told by any number of rogues what his best interests were. If the advisers were friends who appealed to his instinct to help them move up a rung, he was even more of a setup. Later, Bingham says, "Ali was pissed about that impersonation stuff. He had no idea." Why didn't he just say that he didn't make the calls? "You know him," he says. "He'll never betray who he thinks has tried to help him. The idea that people will think less of him now bothers him a lot."

If there was ever any doubt about the staying power of Ali, it is swept aside when you travel with him. His favorite place in the world—next to his worktable at his farm—is an airport. So he should be in high spirits now; he'll be in three airports before the day's over. But he's a bit petulant with Lonnie, who aims to see that he keeps his date at Hilton Head Island. He can't stand hospitals. They get in the way of life. He found it hard even to visit his old sidekick Bundini when he

was dying. Paralyzed from the neck down, Bundini could only move his eyes. Ali bent down close to his ear and whispered, "You in pain?" The eyes signaled "yes." Ali turned his head away, then came back to those eyes, saying, "We had some good times, didn't we?" Bundini's eyes went up and down. Ali talks about this in the Chicago airport. He's calmed down now, sits off by himself, ramrod straight and waiting. He wears a pinstripe suit, red tie, and next to him is his black magician's bag; he never lets it out of his sight. The bag is filled with religious tracts already autographed; which is the first thing he does every day at 6:00 A.M., when he gets up. All he has to do is fill in the person's name.

His autograph ritual and travel are his consuming interests. He'll go anywhere at the ring of a phone, and he spends much time on the road. Perhaps the travel buoys him; he certainly gets an energy charge from people. Soon they begin to drop like birds to his side. "You see," he says, "all I gotta do is sit here. Somethin', ain't it? Why they like me?" He is not trying to be humble, he is genuinely perplexed by the chemistry that exists between himself and other people. "Maybe they just like celebrities," he says. Maybe, he's told, he's much more than a celebrity. He ponders that for a moment, and says, "That right?" By now, a hundred people have lined up in front of him, and a security guard begins to keep them in line. Ali asks them their names, writes, then gives them his autographed tracts. Some ask him to pose for pictures, others kid him about unretiring. He raises his fist: "Kong [Mike Tyson], I'm comin' after you." Near the end, he does a magic trick for a lady, using a fake thumb. "Where you going, Muhammad?" she asks. He thinks, and then leans over to the writer and asks, "Where we going?" The lady's eyes fill, she hugs him and says, "We love you so much." What is it that so movingly draws so many people—his innocent, childlike way, the stony visual he projects, set off against his highly visible symptoms?

That night over dinner, Ali's eyes open and close between courses. He fades in and out of the conversation, has a hint of trouble lifting the fork to his mouth. His every day includes periods like this, he's in and out like a faraway signal. Sometimes he's full of play. He likes to swing his long arm near a person's ear, then create a friction with thumb and forefinger to produce a cricket effect in the ear. Then the play is gone, and so is he. "One day," Lonnie is saying, "I want someone

to catch his soul, to show what a fine human being he is." Ali says, head down, "Nobody know me. I fool 'em all." Lonnie is Ali's fourth wife. She was a little girl who lived across from Ali's old Louisville home when he was at the top. She is a woman of wit and intelligence, with a master's degree in business administration. She plans his trips, is the tough cop with him and his medicine, and generally seems to brighten his life. Ice cream dribbles down Ali's chin. "Now, Muhammad," she says, wiping it away. "You're a big baby." He orders another dessert, then says, "Where are we?" A blade of silence cuts across the table.

Bingham says, "Hilton Head Island."

Ali says, "Ya ever wake up and don't know where you are?" Sure, he is told, steady travel can make a person feel like that for an instant; yet it is obvious that short-term memory for him is like a labyrinth.

Ali's day at the hospital is nearly over. He will soon be counting down the minutes. Right now he's in high spirits. A nurse has secretly slipped him some strips of paper. He has a complete piece of paper in his hands. He crumples the paper, pretends to put it in his mouth, then billows his cheeks until he regurgitates tiny pieces all over his chest. "Ain't magic a happy thing," he says, trying to contain his giggling. When Dr. Medenica comes, Ali jokes with him. The doctor goes about examining the day's results. He looks at the bags of plasma: 15,000 ccs have been moved through Ali. Floyd Patterson has expressed dismay over the current treatment. "No brain damage?" Floyd had said. "Next you'll be hearing he was hit by a cockroach. He's gonna kill Clay . . . he'll drop dead in a year." Medenica bridles at the comment. "He's rather ignorant. I'm going to have to call that man." Ali wants to know what Patterson said. Nobody wants to tell him. "Tell me," says Ali. Everyone looks at each other, and someone finally says: "Floyd says you'll drop dead in a year." Ali shrugs it off: "Floyd mean well."

It is Medenica's contention that Ali suffers from pesticide poisoning. Though his work has met with some skepticism in the medical community, Medenica is respected in South Carolina. His desk is rimmed with pictures of prominent people—a senator, a Saudi prince, an ambassador—patients for whom he has retarded death by cancer. He is supposed to have done wonders

for Marshal Tito of Yugoslavia. Tito was so grateful, he arranged funding for Medenica's clinic in Switzerland. When he died, the funds were cut off and Medenica was left with bills and criminal indictments by the Yugoslavians and the Swiss. "Don't ask how Ali got the pesticides," Medenica says.

Plasmapheresis is a solid treatment for pesticide poisoning, which occurs more than ever these days. The blood cleaning removes the immune complex, which in turn removes toxins. But how can Medenica be so sure that Ali's problem is not brain damage? Dr. Dennis Cope, of UCLA, has said that Ali is a victim of "Parkinson's syndrome secondary to pugilistic brain syndrome." In short, he took too many head shots. Medenica, though, is a confident man.

He predicts Ali will be completely recovered. "I find absolutely no brain damage. The magnetic resonator tests show no damage. Before I took him as a patient, I watched many of his fight films. He did not take many head blows."

Is he kidding?

"No, I do not see many head blows. When he came this summer, he was in bad shape. Poor gait. Difficult speech. Vocal-cord syndrome, extended and inflamed. He is much better. His problem is he misses taking his medicine, and he travels too much. He should be here once a month."

Finally, Ali is helped out of his medical harness. He dresses slowly. Then, ready to go out, he puts that famous upper-teeth clamp on his bottom lip to show determination and circles the doctor with a cocked right fist. His next stop is for an interferon shot. It is used to stimulate the white blood cells. Afterward, he is weak, and there is a certain sadness in his eyes. On the way to the car, he is asked if the treatment helps. He says, "Sheeeet, nothin' help."

The Lincoln Town Car moves through the night. Bingham, who is driving, fumbles with the tape player. Earlier in the day he had searched anxiously for a tape of Whitney Houston doing "The Greatest Love of All," a song written especially for Ali years ago. He had sensed that Ali would be quite low when the day was over, and he wanted something to pick him up. The words, beautiful and haunting, fill the car.

"You hear that," Bingham says, his voice cracking. "Everything's gonna be just fine, Ali."

The dark trees spin by. There is no answer. What is he thinking?

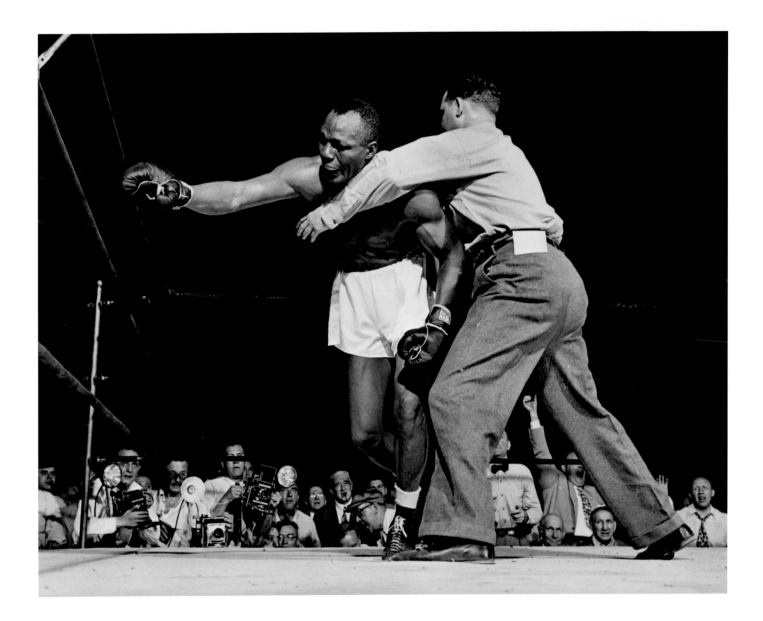

JERSEY JOE WALCOTT (SHOWN) VS. JOE LOUIS, JUNE 25, 1948

110

CHARLES HOFF

RICHARD B. WOODWARD

Boxing is for a sports photographer what a car crash is for a film director: graphic dynamite, fun and safe to play with. The action explodes in a tiny, closed-off square. The sport induces none of the headaches that bedevil camera operators who must shrink football, baseball, hockey, basketball, auto racing, or golf into two dimensions. Pictorial variables aren't spread out but stripped down: a pair of half-naked figures, sometimes linked in the frame by a clothed intermediary; four fleshy columns that ground the figures to the canvas; four snapping lines of deadly force; and a grid of safety ropes, corner poles, hanging lights, microphones, and spectators that locks the picture into place. The violent actors are enlarged by their isolation.

Anticipation is everything in sports photography, and everything in boxing is right there, a few feet away. Anyone with good reflexes and a ringside seat needn't move fast or far to catch the jolting spray of sweat and blood. The cruel purpose and symbolic gestures of the sport are understood everywhere. The arms of the victor raised over the prone body of the opponent are Esperanto for winning and losing.

A few painters have exploited the potent metaphors of the sport, its masculine mystique as a blood rite of Social Darwinism. The hapless club fighters with flailing piston limbs in the work of George Bellows from the 1910s and 1920s are obsolete machines headed for the capitalist junkyard. Writers and film directors have often held up fighters as paragons of "the rite stuff." For Norman Mailer the heavyweight is both existential hero and body double for the novelist himself, slugging it out with literary history. Jake "Raging Bull" LaMotta is Martin Scorsese's symbol of man as blinkered beast.

Boxing rewards the careful examination possible only with the fast shutters, lenses, and lights of stop-action and slow-motion photography. Close up, a camera reveals the facial drama of pain inflicted and endured; it freezes that instant of impact when a punch lands so hard it alters

the accepted proportions of a head. But even if boxing loves photography, it has not been embraced in kind.

Sports has never received the attention it deserves in histories of photography, concerned as many of them are with arguments for the medium as a distinct and estimable art. Photojournalism, the pigeonhole in which sports photography is often confined, seems to muddy the cause of independence. The publication of an athlete's photograph (and the surviving print) may owe as much to the whims of an assignment editor or the demographics and circulation of a magazine as it does to the motivations of the picture taker. The magnitude of events witnessed (murder, war, famine) or persons portrayed (president, rebel leader, title holder) seems to mean as much as—or more than—the unique stylishness of the portrayal, at least to award dispensers such as the Pulitzer committee.

Many contemporary art historians have argued that all pictures are to a large extent social constructions shaped by audiences and institutions. Interesting (or trivial and doctrinaire) as this thesis may be when looking at photographs, it helps only a little in assessing individual talent and deeds. One solution to the problem of how to evaluate sports photojournalism has been to exclude the deadline variety from the canon of Stieglitz and Strand while granting special dispensation to figures such as Martin Munkasci, Leni Riefenstahl, Aaron Siskind, Sid Grossman, William Klein, Geoff Winningham, Garry Winogrand, Lee Friedlander, and Larry Fink, whose images of athletes were produced at a less frenetic pace, and to their own satisfaction and standards as much as for any client's.

The photographs of Charles Hoff in this book, like the New York street photographs of Arthur "Weegee" Fellig, expose the liabilities of this makeshift solution. All of the boxing pictures here were taken on assignment between 1935 and 1966 for the *New York Daily News*, then the most widely read newspaper in the country. They were made to order, shot with the expectation that a picture editor or makeup man would crop them for maximum impact on the back page of a tabloid. A proud and competitive member of the press, Hoff seems never to have vied in arenas beyond the many local and national journalism contests he entered every year.

RICHARD B. WOODWARD

The high quality of his work, however, sets it apart from most sports photographs of the period. In fact, his boxing photographs are as impressive as any single body of work produced by an American from the late 1940s to the mid-1950s. While serving as an almost weekly record of the sport at the peak of its popularity (then second only to baseball), Hoff's images have a startling angularity and coherence that looks forward to the frame-bending experiments of Winogrand and Friedlander during the 1960s and 1970s.

Stroboscopic lighting, which arrests a flow of motion, allowed Hoff to transform portraits of athletes into radical figure studies. Only a still camera in this controlled indoor environment could hope to record these unearthly gestures. Dr. Harold Edgerton, who invented the gas-filled tube for electronic flash in 1938, photographed several bouts in the early 1940s with this new kind of artificial light; and Gjon Mili's multiexposure photographs of athletic action (shot by strobe light) appeared in *Life* magazine about the same time.

But Hoff's photographs are studies in humanity, too. He renders the fighters in these pages—champions such as Joe Louis, Sugar Ray Robinson, Archie Moore, Jake LaMotta, Kid Gavilan, and Rocky Marciano, as well as many all-but-forgotten gladiators—in all their elegance and pain. No fight fan over forty could look at these pictures and not feel moved.

Hoff was in the right place at the right time. He covered sports before television ruled, when a half-tone reproduction in a newspaper might be the only visual record a fan ever had of the previous night's game or match. Photographers illuminated the cloaked figures of radio. The *Daily News* was the leading picture paper in the country, with a Sunday circulation over four million in 1947. The camera logo on their front page is a relic of that era in technology, before live video feeds from war zones. New York City in the 1940s and 1950s was also the Mecca of boxing, amateur and professional. From his privileged spot in the middle of the first row at ringside on the Fiftieth Street side of the old Madison Square Garden, Hoff caught all the big fights during what was undoubtedly a golden age of boxing.

It may be as dangerous to make too much of Hoff's achievement as too little. He lacked the omnivorous appetite for urban life found in Weegee's work, an admirable quality that also keeps

sizzlingly alive yesterday's news from journalists such as A. J. Liebling and Joseph Mitchell. Hoff relied as much on preparation and control as Weegee did on stealth and freewheeling improvisation.

But even if he was just lucky or his photographs are only the best of their kind that have so far surfaced among tens of thousands of prints from those years, they should shake up some engrained notions about the lowly place of sports journalism in the annals of the medium. Hoff's dynamic eye for composition was unusual by any standard. He was an artist in spite of his credentials.

Charles Hoff might be more identified with his fight pictures if he hadn't also taken one, a good deal more famous, of an American catastrophe. In a sense it was the picture of his life. He was only thirty-two years old when he struck what quickly became an icon of the twentieth century.

One of more than a dozen photographers awaiting the evening arrival of the eight-hundred-foot German dirigible *Hindenburg* at Lakehurst, New Jersey, on May 6, 1937, Hoff kept a dispassionate head (unlike the renowned radio broadcaster who was there) when the hull suddenly erupted in flame while docking. "It started doubling up as it fell," he later wrote in the *Daily News*. "I didn't think of the people on it as I watched. I didn't think of the beautiful thing I had looked at a minute before. I only tried to keep my hands from trembling as I slid plates into the camera." The fire left thirty-six dead, making it one of the worst air calamities of the decade.

Although it was one of many published versions of the disaster, Hoff's picture (perhaps because it made the cover of the *Daily News* on May 7) won him his first major award: Best Feature Photograph from the New York Press Photographers Association. For years a mural-sized blowup occupied pride of place on the wall at the entrance to the Photography Department at the newspaper offices on Forty-second Street, and to many of the people with whom Hoff worked, this spectacular shot was his main legacy. The headline to his obituary in the April 8, 1975, issue reads: "Charles Hoff Dies: Hindenburg Photog." Only one sentence was devoted to his boxing photographs.

This scoop was more the result of accident and reflex than of the meticulous planning that was a Hoff trademark. But it featured the explosive illumination he had grown fond of. Dramatic backlighting also figured in another celebrated shot he took almost twenty years later: Bob Barksdale breaking a twenty-two-year high jump record at Madison Square Garden in 1956. Hoff caught the Morgan State University athlete at the top of his leap, clearing the bar at 6'9", and he haloed his subject with the same silvery burst of light. Only this time the source was three electronic

flashlamps carefully placed in the balcony and mezzanine. The picture, maybe Hoff's best known after that of the *Hindenburg*, filled the back page of the *Daily News* and took the grand prize in *Look* magazine's photography contest for the year.

Born March 11, 1905, in Coney Island to Theodore and Sophie Hoff, Charles seems to have inherited a penchant for journalism and photography from his father, a first-generation German-Polish Jew who worked briefly for Reuters before opening a camera shop on the boardwalk. Charles was the second child of four. His oldest brother, William, grew up to head public relations for the Marine Air Terminal at La Guardia Airport; Edward worked as a publicity man in Hollywood; and Rose was a commercial photographer on Long Island.

When and why Charles Hoff first picked up a camera in earnest is unclear. However it happened, he must have showed talent and ambition. He was the first male student to graduate from Erasmus High School in Brooklyn with a commercial degree in, of all things, stenography. But by his early twenties he was photographing for the *Brooklyn Eagle*, moving on in 1927 to a staff job at the *New York Daily Mirror*, where he worked for six years. He joined the *Daily News* in December 1933.

As an adult, Hoff devoted his skills to the sports beat, though he had trained as a police and general assignment photographer. Throughout his thirty-four-year career at the *Daily News*, picture editors sent him off to bring back visual reports of all kinds, everything from floods and ribbon-cutting ceremonies to surveillance of suspected Soviet spies. It was a dream job for a news photographer, not as prestigious as working for *Life*, but offering daily opportunities to be published and probably more fun.

During the years just before World War II and for a few years after, Hoff was a "flying cameraman," providing aerial angles on events all over the East Coast. He accompanied reporters aboard various aircraft, including the paper's own *Miss Daily News*, a Grumman Mallard amphibious plane equipped with a darkroom. Hoff might be called on to search for air crash survivors in Newfoundland or to rush down to the Preakness and back. Schmoozing with and photographing big-name politicians was another of his specialities. For thirty years he covered

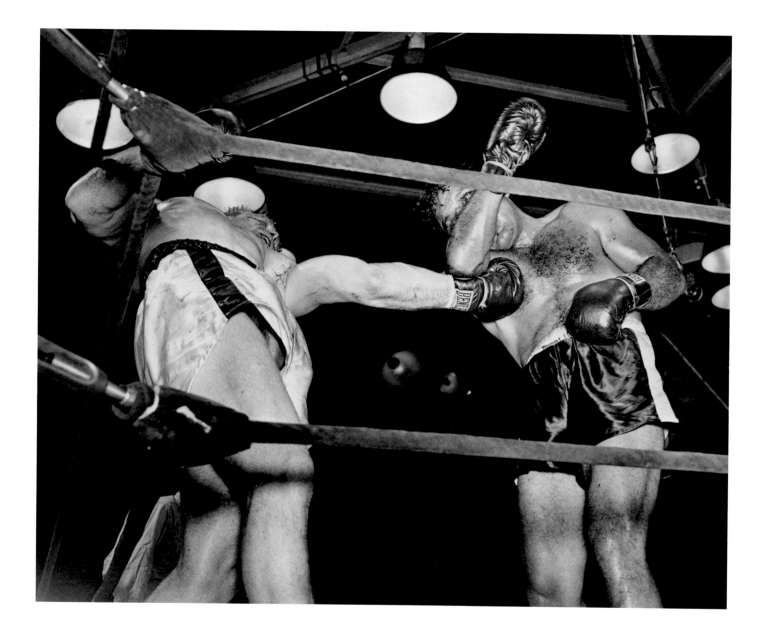

ROBERT VILLEMAIN VS. JAKE LA MOTTA, MARCH 25, 1949

117

every presidential convention and inauguration. He was one of twenty-five members of a staff that won the Pulitzer Prize for "its consistently excellent news picture coverage" during 1955.

A versatile professional, Hoff learned over the years to handle the Fairchild aerial camera, twin-lens reflexes, and Hasselblads, as well as the news photographer's standard issue in the 1940s and 1950s, the boxy Speed Graphic. Different events called for different equipment. For baseball he used a Graphic, adapted with a 5-by-7-inch film holder and a 40-inch lens (equivalent to a 1,000-mm telephoto). Nicknamed "Big Bertha," it had a clutch with settings that allowed for pre-focusing on first, second, third, and home. (Late in life, Hoff even had an optometrist in Flushing design a pair of glasses that fit over the viewfinder of this camera.)

Dan Farrell, a staff photographer still at the *Daily News* and one of the last alive to have known Hoff well, worked as a young motorcycle courier at afternoon baseball games in the 1950s and early 1960s. It was his job to pick up the exposed negatives and the captions at 3 P.M., and to speed them to the paper in time for the negatives to be developed and printed in the "pink edition," which hit the streets at 7:00 that night.

"Charlie was a demanding guy who didn't like to leave anything to chance," says Farrell. "He would always insist on dictating the captions or writing them himself." Farrell recalls Hoff vividly as "this little fellow, no more than 5'5" who would be dressed at the park in cowboy clothes and hat," a sartorial habit he seems to have assumed covering the New York Giants at spring training in Arizona during the late 1940s. On formal occasions, however, Hoff was far more dapper, with slicked-back hair, bow tie, and jacket.

Ron Hoff, who works in circulation at the *Daily News*, remembers his father as an "absolute perfectionist" who carried a camera everywhere. "He was always photographing my sister and me as kids. But he wouldn't take the picture until he thought it was right. It was 'wet your lips, stand there, move your head.' He would wait and wait until you posed the way he wanted."

Sports photography is more about waiting than about searching for things to happen. It depends on staking out a spot and anticipating when the action will reach a peak of visual excitement inside the frame.

The *Daily News* had advantages over the competition when it came to finding the ideal

vantage point from which to photograph a boxing match. As perhaps the top sports newspaper as well as the leading picture daily, it could claim prime real estate from promoters. At Madison Square Garden, Hoff would have his central spot at ringside while rivals from other papers were bunched up in the corners.

The *Daily News* also had a long tradition as a sponsor of the Golden Gloves. Paul Gallico, a sportswriter at the paper from 1924 to 1936, helped establish the Golden Gloves as the top amateur boxing tournament in the country during the late 1920s. What's more, Dan Farrell's father, an electrician who had wired events at the Garden since the 1920s and at Yankee Stadium and the Polo Grounds whenever a major bout was scheduled, saw to it that the *Daily News* photographers enjoyed favorable working conditions. Thus, the paper had the incentive to invest in expensive equipment for producing unusual pictures while other organizations didn't see the need or couldn't afford it.

A fight required elaborate arrangements for shooting either indoors or at night outdoors. For any athletic event, recalls Farrell, Hoff would always arrive long before it started. "He was very big on preparation. He wanted to check out the field, test the lights, eliminate any possible errors. He was on top of things. But he could be pretty aggressive in getting what he wanted." Farrell's father had a kitchen in the recesses of the Garden; after the equipment was set up to his satisfaction, Hoff would join the electrician for an early dinner. "It was great because you didn't have to eat in those Eighth Avenue joints," says Farrell. "They'd sit around, have a few drinks. Charlie liked to take a nip. He always had a couple of jugs in the darkroom."

Hoff had a costly rig of stroboscopic speedlights that weighed more than three hundred pounds and had to be pushed around on a dolly. Operating on AC house current through four power packs that fit underneath the boxing ring (with a master under the control of the photographer), they could freeze action at 1/3,000 to 1/30,000 of a second. Running between the master and a switch built into the shutter of the camera was an electric wire known as the tripper cord. It synchronized the tripping of the shutter and the explosion of light from the three flashlamps inside large reflectors over the ring.

Hoff contributed several times to a photography column in the paper called "Camera

College." In a piece from 1953, he extolled speedlights as "the greatest single advance in our working equipment in twenty years. . . . The sports photographer's biggest problems used to be such things as stopping the motion of a hockey puck traveling eighty miles an hour, a kayo punch landing on the chin or a hurdler taking the last jump at a track meet. The speedlight has solved that for us."

He went on to describe technical details of his camera settings under these lights (a shutter speed of 1/400 of a second and the lens closed down to f/11 for near-maximum depth of field) as well as their array. "One light is hung above me and ten feet to the left, another is ten feet to the right, and the third is used to provide a little side light."

According to Farrell, who inherited the center-ringside seat at the Garden after Hoff retired: "The lighting for boxing matches in those days was incredible. You won't ever see it again. Boxing is a sport for television now, and the networks wouldn't permit flashes of that size going off and interrupting their broadcasts. With the speedlights you could stop down to f/22 and everything would be in focus straight across the ring. You didn't have to change the diaphragm or the shutter speed. You just set the 135-mm lens for six feet, cocked the shutter, and waited your chance."

About the process of seeing and shooting the action, Hoff wrote: "You can't see it happen and then shoot. You have to learn to shoot instinctively. AS IT HAPPENS." Farrell and others agree that Hoff's keen sense of timing produced many more hits than misses. He didn't waste film. "He was known as 'One-shot Charlie,'" says Pat Carroll, a studio apprentice in the *Daily News* Photography Department during the 1950s.

"With the Speed Graphic you had to learn to hold the camera out in front of you, so you didn't look in the viewfinder," says Farrell. "He told me he would watch the fighters' feet so that he could tell when they were about to throw a punch that might land with some power. That was how he was able to get those so-called 'rubber faces' shots." The picture in this vein that Hoff was proudest of, says his son, shows Kid Gavilan being pounded by Sugar Ray Robinson during a 1948 title bout in New York [page 123]. The photograph won prizes in five contests.

The strobe lighting and deep focus accounts for the eerie three-dimensionality of the box-

ers in Hoff's pictures. But he also arranged his actors in an energetic relationship with the ropes, the lights, the spectators, and even other photographers. He was after more than just rubber faces. The pathos of men fighting for their dignity (as well as money, fame, and a title) has rarely, if ever, been better expressed in still pictures.

The choreography of boxing—the intricate system of balances that govern a body that has just thrown, landed, or received a punch—is the subject of these pictures as much as who won or lost that night. Jersey Joe Walcott and the referee in the picture taken during a bout at the Garden in 1948 [page 110] seem to be ballroom dancing—not in the fans' catcalling sense (when two fighters spend too much time during a round in clinches, they are hooted at for "dancing") but instead like a couple in a Depression-era marathon. Walcott reaches out in desperation, a gesture imploring the rope to move closer before he goes down. The spectators behind the press row shout encouragement or outrage, and the photographers lift their cameras as he hits the canvas.

Hoff's boxers aren't raging beasts but fragile figurines, often carefully arranged as though on a toy shelf. In several pictures opponents stand toe-to-toe, almost touching. The space in between becomes the focus of the picture, adding to the tension of pairs of legs flexed like bridge supports. Formal niceties aside, Hoff also portrayed the brain-shaking violence of the sport, the shattering effect of a blow to the head as well as the unconscious aftermath. The dead gaze on the boxer's face as he topples over like a broken statue [page 124] is brutal, comical, and sad. Although he has just been knocked out cold, one arm is still upraised for combat and neither limb is going to break his hard fall. For the micromoment he still stands, like Chaplin or Keaton, at an impossible forty-degree angle.

Many of these photographs were too strange for the pages of a tabloid newspaper. Even brutally cropped, they would never be readable as illustrations for a story on a sporting event. The contortions of Jake LaMotta and Robert Villemain [page 117] as they battle amid a thicket of lights, wires, and ropes during a 1949 fight make for a picture that holds together shockingly well corner-to-corner. But it would have been unintelligible in any newspaper of the day.

Hoff seems to have recognized as much; most of the pictures in this book never appeared

in the *Daily News*. But he made a special set of prints for the managing editor, Bob Shand, who was both a boxing and a Charles Hoff fan. Shand was said to have kept some Hoff pictures in his drawer which he would pull out and study whenever he had a moment.

Hoff's last years at the paper, in the 1960s, were not as happy as earlier decades. His preferred assignment was hockey, which he photographed without a glass partition to protect him. Some of the staff resented his eagerness to enter contests and gather prizes. Jack Smith, a forty-five-year veteran of the paper, thinks that "Charlie always won first prize because he was the only one who remembered to send in the clippings to enter. He won on sheer volume." (Hoff ended up with 124 local, national, and international awards.)

His competitive need to appear in print as often as possible was also an irritant. "He would call the makeup guy and ask, 'What way does the back page go?,'" says Smith. "Then he would tell them to crop his pictures whichever way that was. Charlie had enough sense to know how to fill a hole. If you can make it easy for the makeup guy, you'll get a lot of pictures in the paper."

Friendlier with colleagues at the *Daily Mirror* and the Associated Press than at his own paper, Hoff was seen as a bit of a loner. "I think he was probably appreciated more by photographers at other papers than he was here," says the *Daily News* cartoonist Bill Gallo. Hoff also suspected there was an anti-Semitic bias against him.

"A lot of people hated him because he was doing what *they* wanted to do," says Farrell. "But Charlie got it done, whatever you needed. He showed me how to be a photographer. He taught me what I needed to know."

In 1967 Hoff damaged his spine when a fighter fell out of the ring and on top of him. A year later he retired. "He was never the same after the injury," says Ron Hoff. "Toward the end of his life he was kind of a recluse. He couldn't care less who won the pennant. But he liked to take pictures. When my son was born he took about a gazillion." In 1974 Hoff moved with his wife from Kew Gardens in Queens to Hallandale, Florida, where a year later he died of a stroke at the age of seventy.

Was Hoff the preeminent sports photographer of his day? He was regarded as one of the

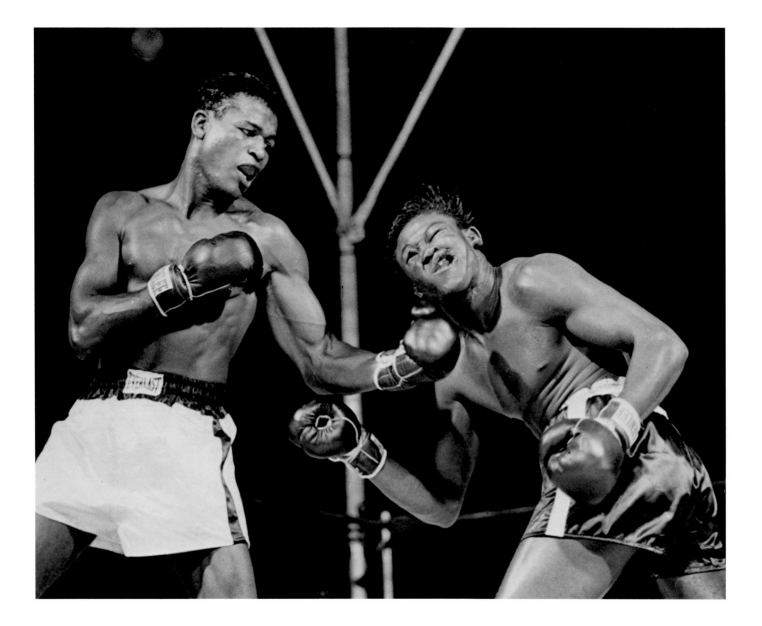

SUGAR RAY ROBINSON VS. KID GAVILAN, SEPTEMBER 23, 1948

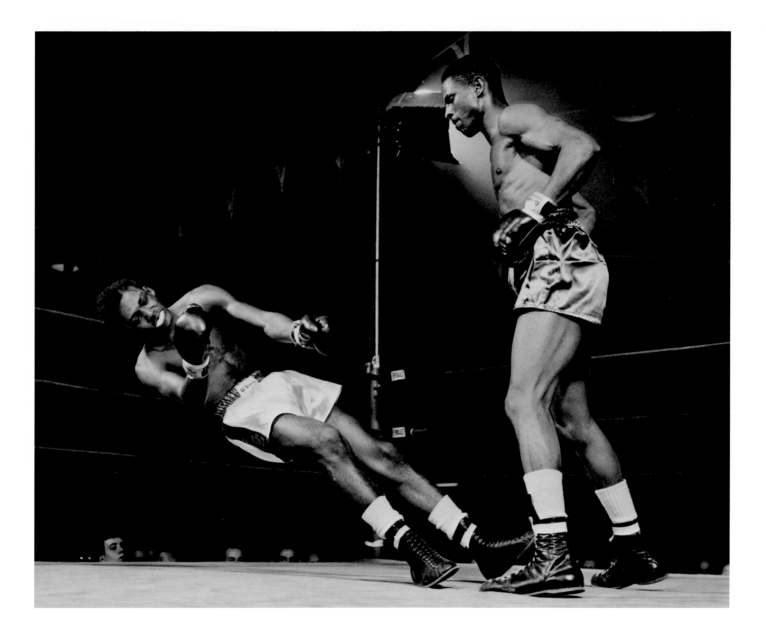

best during his life, with the awards to prove it, including three first prizes from *Look*, generally a more daring forum for photography than *Life*. There were four Hoff photographs (three of boxing) in the 1973 Museum of Modern Art show *From the Picture Press*. Another picture, of Marciano catching Ezzard Charles with a right uppercut during a 1954 fight at Yankee Stadium, can be found in the permanent collection of the museum. Hoff's boxing photographs can also be found in The J. Paul Getty Museum and The National Portrait Gallery.

But until a comprehensive exhibition of sports photography is mounted from the archives of newspapers and magazines in the United States, the former Soviet Union, and Europe, Hoff's place in history will be insecure. His baseball, horse racing, track-and-field, hockey, Soviet espionage, and human interest pictures prove that he was a top-notch professional newspaperman. Only at the fights did he produce a body of truly extraordinary work.

Even so, Hoff's portraits of lauded champions and nameless also-rans transcend the disposable papers for which they were intended. These fighters, like Weegee's cops and crime victims or O. Winston Link's locomotives, are nostalgic ghosts of the black-and-white era and, in their own way, futuristic glimpses of bodies in motion. During the middle years of the century when photojournalists were heavy-weights among image-makers of the world, Hoff was more than a contender. For a couple of decades he reigned as a supreme elegist of athletic achievement. Few ever after have done it better.

ACKNOWLEDGMENTS

I want to express my appreciation to the following individuals who contributed to the preparation of this book. Ron Hoff, Bill Gallo, Dan Farrell, Faigi Rosenthal, Pat Carroll, Jack Smith, and Mike Lipack of the *Daily News* provided essential information about Charles Hoff and his photographs. Herbert R. Goldman, editor of *International Boxing Digest*, and Nathaniel R. Loubet, former publisher and editor of *The Ring* Magazine, helped to identify the boxers and date the fights pictured. Howard Greenberg loaned the vintage prints from which duotone reproductions were made. Julie De Witt, Roger Straus, III, and Robert Gordon offered advice and support throughout the project. I am also grateful to Caroline Herter for publishing the book and Emily Miller for attending to endless details.

C. S.

DATE DUE

HIGHSMITH #45115